IMAGES
of America

ROCK HILL
SOUTH CAROLINA

IMAGES
of America

ROCK HILL
SOUTH CAROLINA

Ron Chepesiuk

ARCADIA
PUBLISHING

Published by Arcadia Publishing
Charleston, South Carolina

Printed in the United States of America

Library of Congress Catalog Card Number: 2001096357

For all general information contact Arcadia Publishing at:
Telephone 843-853-2070
Fax 843-853-0044
E-mail sales@arcadiapublishing.com
For customer service and orders:
Toll-Free 1-888-313-2665

Visit us on the Internet at www.arcadiapublishing.com

CONTENTS

FOREWORD

During the span of my lifetime, Rock Hill has grown from a railroad town of 29,000 people to a thriving city of more than 52,000 citizens. An economy once based primarily upon textiles has become a diverse one that includes cutting-edge, 21st-century technology.

Amidst this economic prosperity, Rock Hill is a community that values its 150 years of history and tradition. The city is working to grow in a way that celebrates its rich heritage while creating an even more prosperous and secure future for its citizens.

Rock Hill has been home to Winthrop University for more than a century. Winthrop has been integral to the history of Rock Hill and will play an important role in the progress it will achieve in the 21st century. It is therefore appropriate that this book is being published by Winthrop University as a chronicle of the community and its people.

The experiences of the past shape our future. Enjoy this very special opportunity to reflect upon the past and consider our future.

Congratulations to Rock Hill upon its 150th anniversary!

Jim Hodges
Governor of South Carolina

A Message from
Dr. Anthony J. DiGiorgio

In honor of Rock Hill's 150th anniversary, Winthrop University is proud to make available this photo album for the enjoyment of the city's citizens and friends. As readers peruse these pages, Winthrop hopes that each will garner an enhanced appreciation of the people, places, and events that have shaped our community.

Survey the past 150 years and it quickly becomes apparent that Rock Hill has had a remarkable history—one that has been full of challenges. Yet the city also has seen steady development from its humble beginnings as a small village growing up around a railway depot. Today, Rock Hill is a lively city blessed with productive and community-minded citizens, dynamic institutions, and thriving businesses.

Winthrop University has been an integral part of the community's heritage since Rock Hill won a competition that brought the institution here as a small women's college in 1895. Since then, Winthrop has shared in Rock Hill's growth and prosperity and in its changes. In 1974, Winthrop became a co-educational institution, and in 1992, it attained university status—a milestone that marked the beginning of an exciting new era on campus. Today, Winthrop is a comprehensive learning institution offering undergraduate and graduate degrees to more than 6,000 students from around the world. Over the years, many of the University's graduates have become leaders in the Rock Hill community as educators, entrepreneurs, and other professionals. Today, Winthrop faculty, staff, and students continue a long history of dedicated service to the community and to South Carolina.

In all these ways, the bonds between Winthrop and its host community have strengthened with time. That is why, in commemorating this milestone birthday for Rock Hill, we also celebrate the long and illustrious tradition of cooperation between Winthrop University and this most special community.

Happy 150th, Rock Hill!

Dr. Anthony J. DiGiorgio
President, Winthrop University

A MESSAGE FROM JOHN HARDIN

I was born and raised in Rock Hill and have been actively involved in Rock Hill's affairs over the past five decades as a school board member, city councilman, and mayor. I have watched with pride as our community mushroomed from a small village of 6,000 inhabitants to a vibrant city of more than 50,000.

In 1952, when Rock Hill celebrated its 100-year anniversary, I had the great honor and pleasure of participating in that historic event as its treasurer. Indeed, Rock Hill has much to celebrate, as it continues to grow and prosper. In 2002, we reached another historic milestone—Rock Hill is now 150 years old.

It is remarkable to see how far our community has come since it began as a little village springing up around a small railway depot nearly a decade before the American Civil War. As our city grew, many factors played an important role in making our community what it is today. The textile history, the selection of Rock Hill as the location for Winthrop University in 1895, and the early agricultural roots of the area should not be forgotten. These factors as well as others have shaped Rock Hill's character—the community's friendly southern nature toward visitors and each other, its tenacious desire to succeed, openness in meeting new challenges, and willingness to move in new directions.

We have come a long way. Today, Rock Hill is by all measures a winner—an All-American city and a dynamic part of what historians have called the New South.

Over the past 150 years, Rock Hill has been blessed with many people and businesses that have contributed to its prosperity and civic pride. This special photo album will introduce you to some of them. Given Winthrop's major impact on our city, it is only fitting that the university has published this book. Many of the images come from the Winthrop Archives, which has played an important role in documenting Rock Hill's history during the past 30 years. Hundreds of donors from all walks of life have shared their family mementos with the Winthrop Archives. In preparing the photo book, citizens have stepped forward, contacted the author, and contributed more personal and family photographs. It is this generous community spirit that defines all things Rock Hill.

So, Winthrop, I hope you enjoy this photo album and take the time to celebrate Rock Hill's 150th birthday celebrations. As William Shakespeare once said, "What is past is prologue."

John Hardin
Rock Hill Citizen

One

BEFORE 1900

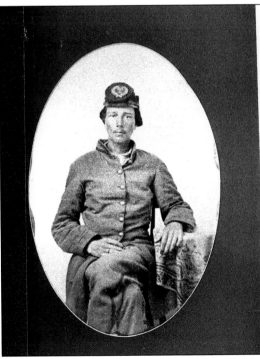

AWOL

On the cold wet banks of the river,
the news found him camped.
A soldier of the Confederacy.
A Catawba from Carolina, trapped
in the garb of grey
and his word to stay
until the fight was done.
But the news made him stray
and he headed home to see his newborn son.

Two hundred miles he tread alone,
through skirmish and devastion,
bound for home, back to the Catawba Nation.

He stayed a month with mother and child,
he watched his son for hours.
He fished the banks of the river,
and lay with his wife among the flowers.
He basked in the love of his family
and enjoyed his fatherhood.
Yet he couldn't stay for good.

Away without leave,
he walked back to his kinsman in Company G
Fifth South Carolina Infantry
risking the hangman's rope
for clemency he had little hope.
But they didn't hang him, no anger on him was spent,
and he died sometime later of disease in a crowded tent.

He was laid
in an unmarked grave
another Rebel who fell
but he left a story of strength to tell.
Robert Head had met his only son
and returned to see his duty done.

This Catawba trapped in the garb of grey
and his word to stay
until the fight was done.

Wayne K. Head

Catawba Indian Robert Head served in the Confederate Army during the Civil War. A relative penned a poetic tribute to his service. In the Civil War, Rock Hill and York County suffered the highest casualty rate among South Carolina counties, with 805 killed and many more wounded. Many of the casualties occurred during the last year of the war.

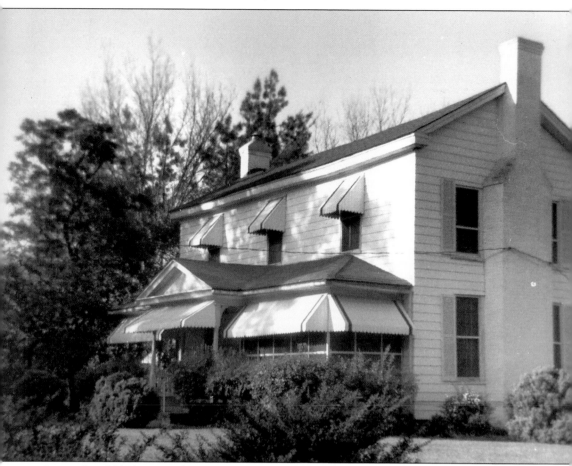

Located in Old Ebenezerville, the Neely Home was built by John R. Hall in 1865 and included an old outside kitchen and two acres of land. This was the home site of the Neely family for more than 80 years. The house was 111 years old when it was torn down in the spring of 1976 and replaced by the present cul de sac of Neely Court on Ebenezer Road.

Pictured here are two early ministers of St. John Methodist Church, Rev. Robert Barber, above, who served from 1876 to 1877, and Rev. James Boyd, below, who served from 1877 to 1881. Established in 1857, St. John's Methodist Church was the only local church for Methodists at the time. In 1968, the congregation changed its name to the United Methodist Church.

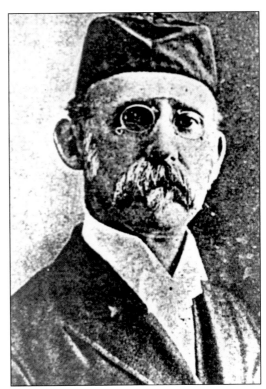

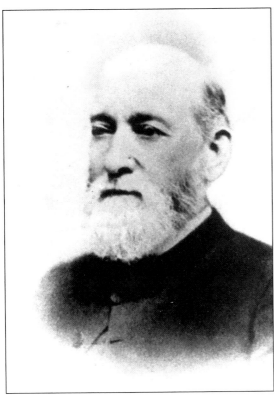

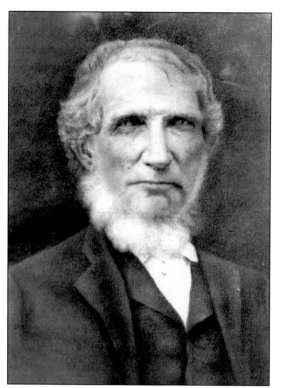

Alexander Faulkner Fewell (1819–1891) was a leading local citizen in the latter part of the 19th century. He was a prominent planter and merchant and before moving to Ebenezerville he owned upwards of 800 acres east of what is today Rock Hill. He was often referred to as a "prince among agriculturalists." His son Alexander Faulkner Fewell was also a well-known merchant and planter who fought in the Civil War.

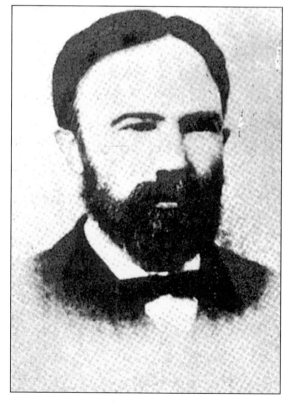

The Reverend James Spratt White (1841–1891) is credited with founding Rock Hill Public Library. Rock Hill's first library association was organized in 1884, when 33 citizens met in Roddey's Hall in response to a public invitation issued by Reverend White. All 33 became members of the association and elected officers as follows: J.S. White (president), J.M. Ivy (vice-president), W.J. Roddey (recording secretary), D.D. Moore (librarian and treasurer), and J.R. London, W.B. Jennings, J.B. Traywick, and J.J. Waters (directors).

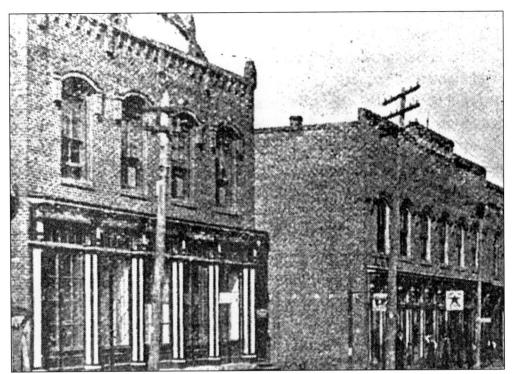

This grainy photo shows the building that housed the Rock Hill library after it was moved to its new location at the corner of Elk and Main in November 1884. The cornerstone was laid August 28, 1884, and the library received its formal charter on October 1 of that year.

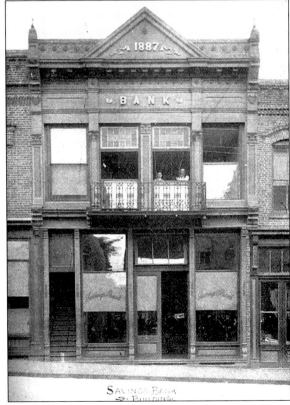

Established in 1887, the Savings Bank Building was the financial institution where many Rock Hillians were putting their money by the mid-1890s.

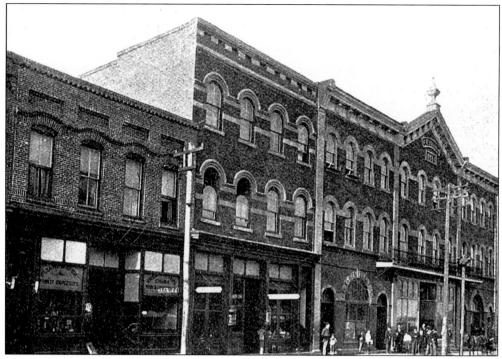

The Roddey Building was one of Rock Hill's most important structures in the late 19th century.

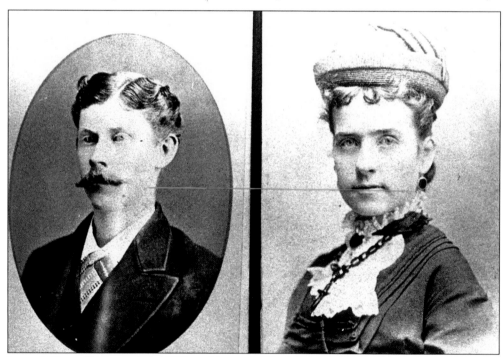

James Milton Cherry (1856–1920) and his wife Ella Moubray Davis Cherry (1854–1922) are pictured above. Mr. Cherry was one of Rock Hill's early leading businessmen. Cherry Road and Cherry Park are named in his honor.

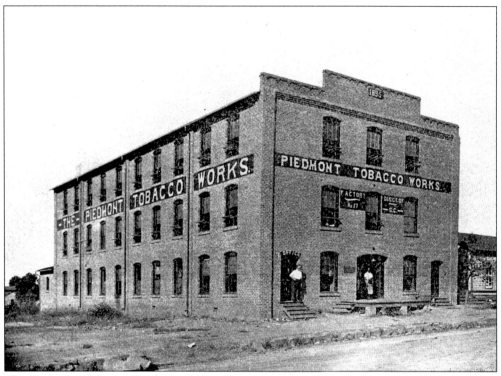

The Piedmont Tobacco Works was a thriving business in the late 19th century.

David Bancroft Johnson (1856–1928), the founder and first president of Winthrop University, is seen to the right. In 1950, *The State* newspaper polled its readers on whom they thought was the outstanding South Carolinian of the first half of the 20th century. David Bancroft Johnson was chosen. The educator was superintendent of the Columbia school system before helping to establish Winthrop in Columbia in 1886. Winthrop opened its doors in Rock Hill in 1895.

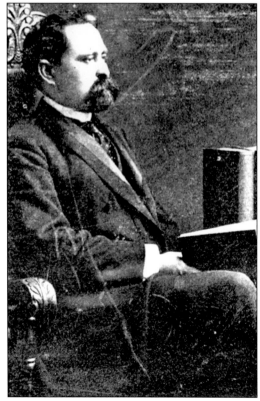

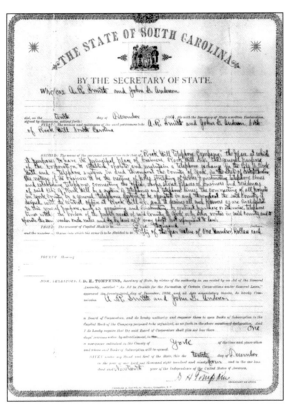

The original charter for the Rock Hill Telephone Company issued on December 10, 1894, to John Gary Anderson and Andrew Rhett Smith is pictured to the left. The company was capitalized at $5,000. Anderson and his new partner, James Milton Cherry, sold his interest in the company to Smith and Paul Workman. Workman bought out Smith in 1907 and later sold the company to Mr. and Mrs. E.L. Barnes in 1912.

This unidentified and undated photo from the White family papers in the Winthrop Archives shows some local African-American residents. The photo probably dates to the 1890s.

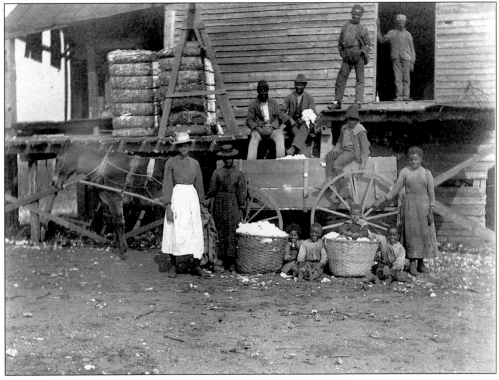

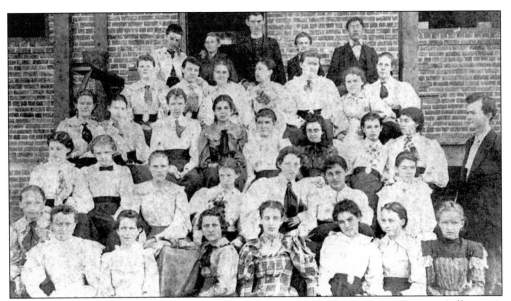

Rock Hill Graded School Class of 1895, which was taught by professor R. Ben Sullivan, is seen above. The people in the photo are, from left to right, as follows: (first row) Rem Barrett, Barron Steele, Knox Roach, Claude Creighton, and Fred Tompkins; (second row) Mary Hall, Mary May, Edna Hull, Fanny Freidheim, Julia Simpson, Mary Gettys, and Margaret Roach; (third row) Janie Wylie, Amelia Beckham, Jenny Russell, Lottie Blake, Mayme Poag, Carrie Harmon, Kathleen Moore, Mary Marshall, and Professor Sullivan; (fourth row) Jeanie Sprunt, Mamie Cummings, Lizzie Hall, Fanny Wilson, Nell Reid, Sadie Freidheim, and Sadie Adams; (fifth row) Vista Wood, Mamie Adams, Maude Chaplan, Willie Harrison, Scotia Reid, Alta Fewell, Annie Boney, and Daisy Huey.

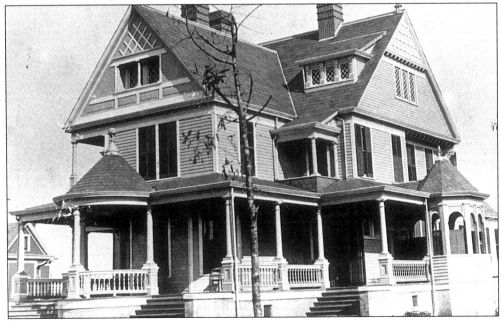

James Milton Cherry's home is pictured above. Built in 1895, the house stood at 200 Oakland Avenue, the site where the law offices of Harrelson, Hayes and Guyton are today.

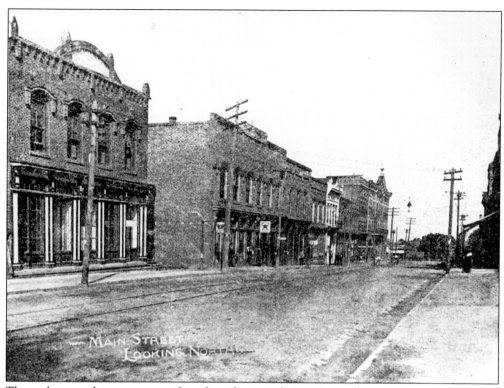

These photographs present a north and south view of Main Street about 1895.

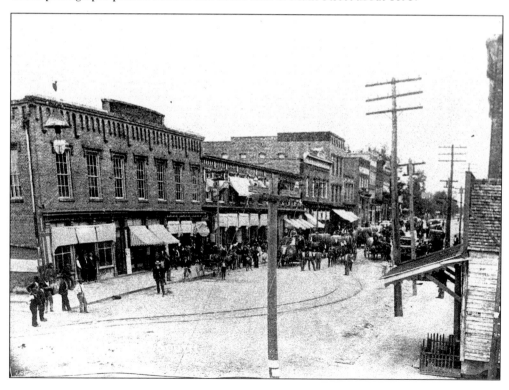

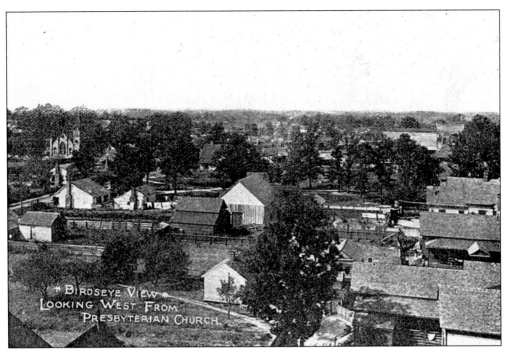

This photograph shows a bird's-eye view of Rock Hill looking west from the Presbyterian Church in the mid-1890s.

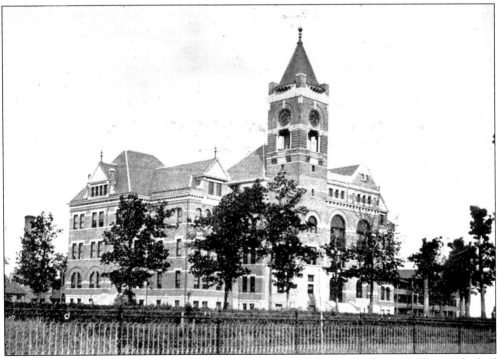

This photograph provides a view of Main Building (later known as Tillman Hall), as it looked soon after Winthrop's move from Columbia to Rock Hill in 1895. Main Building was completed in 1894, and more than 100 years later, it still serves as the focus of Winthrop life.

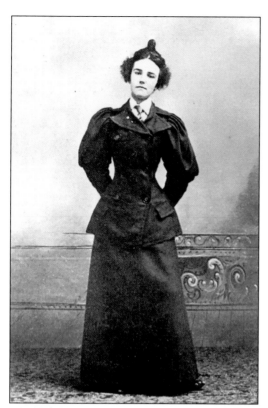

Winthrop student Mary Brock of Chesterfield was photographed in her fatigue uniform during the 1895–1896 school term—the college's first academic year after its move to Rock Hill. Winthrop students wore uniforms until 1955.

The home below, the residence of George P. and Ann Hutchison White, is the oldest home in Rock Hill. The photo shows the home as it looked in the late 1890s.

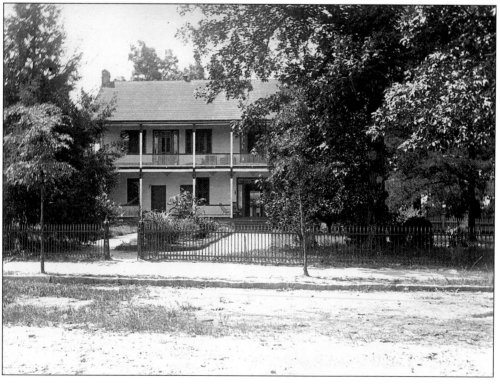

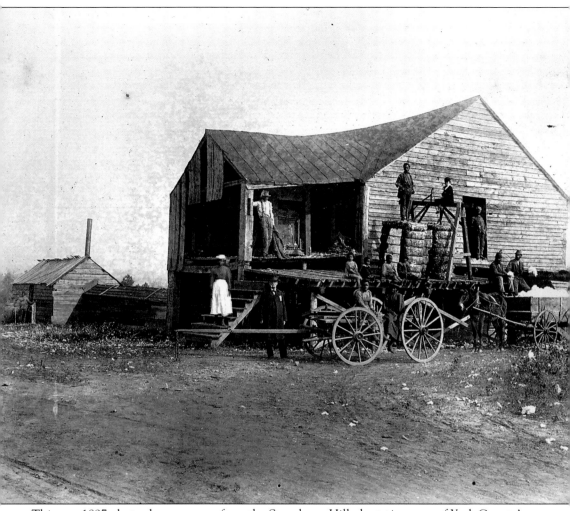

This rare 1897 photo shows a scene from the Strawberry Hill plantation, one of York County's largest plantations. Located on Jones Avenue, the plantation was owned at the time by Capt. Iredell Jones, one of Rock Hill's leading citizens and the president of the Board of Trustees of Rock Hill Graded School.

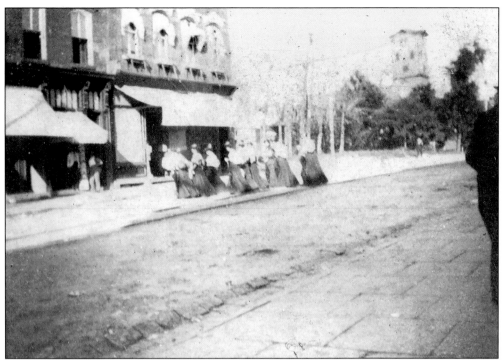

This photograph provides an unusual view of Winthrop students out on the town in the late 1890s.

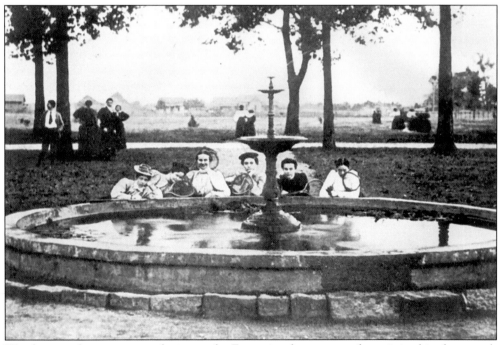

Winthrop students are seen relaxing at the Fountain after a game of tennis in this photograph taken in the late 1890s. Notice Oakland Avenue in the background and the area where Dinkins Student Union now stands.

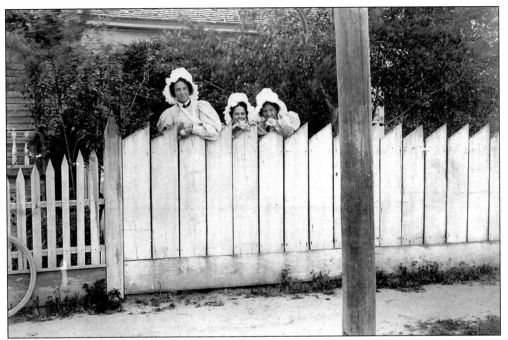

This photo from the Winthrop Archives, which was taken in an unknown location in April 1897 by an unknown photographer, is titled "The cats on our back fence." From left to right are Georgie Charlton, Sally Kintzer, and Mary Joe Witherspoon.

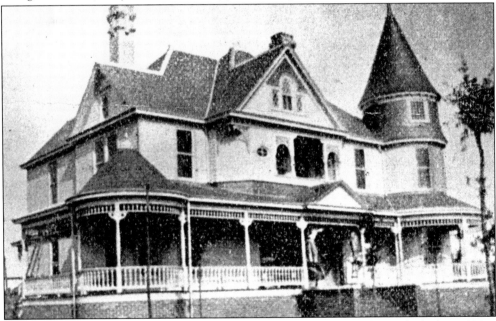

The Oakland Avenue residence of John Gary Anderson (1861–1936) as it looked in 1899 is seen above. In July 1888, two years after his marriage, Mr. Anderson opened up a small repair shop in the rear of his father-in-law's Rock Hill furniture store. In addition to managing the store, the young entrepreneur worked on the construction of the horse-drawn buggy. This was the beginning of the Rock Hill Buggy Company and the John Gary Anderson legend.

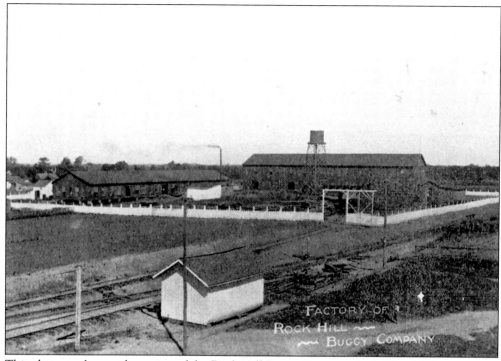

This photograph provides a view of the Rock Hill Buggy Company in the late 1890s.

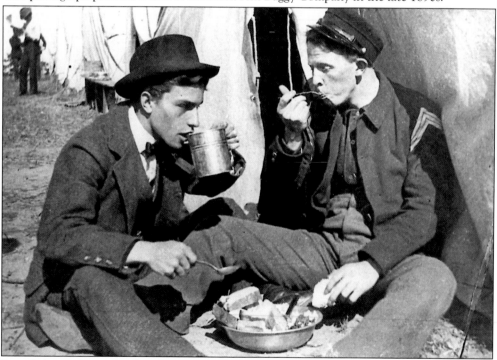

From left to right are Rock Hillians James Spratt White II and J.C. Witherspoon as they have their first breakfast during their participation in the Spanish American War. The photo was taken in 1898.

Rock Hillians gather in the late 19th century to witness the laying of the first street car tracks.

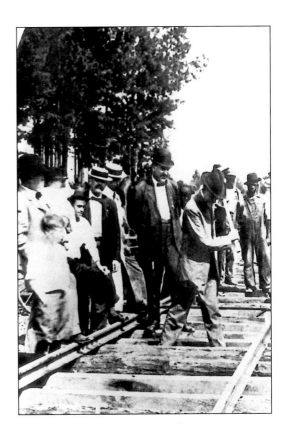

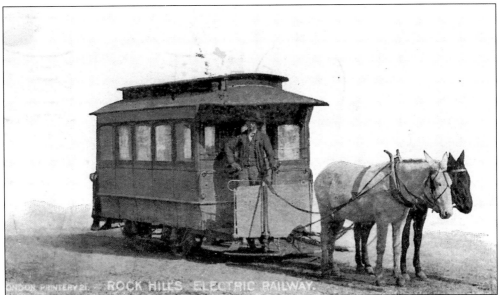

Rock Hill's so called "Electric Railway" operated at the turn of the century. Some old timers said the name "Electric" came from the fact that two horses were humorously named "Lec" and "Tric." This photo was taken about 1900 in front of the Presbyterian Church. The driver of the streetcar was Calvin Youngblood.

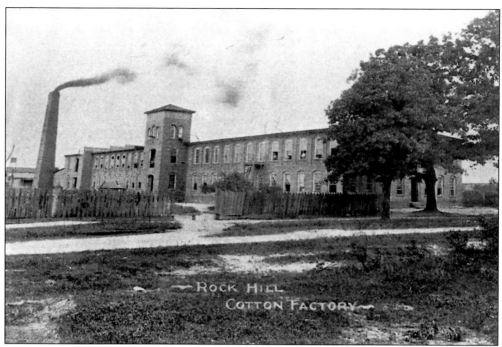

By the late 19th century, Rock Hill was an agricultural hub, as these two mills show—the Rock Hill Cotton Factory (above) and the Arcadia Mill (below).

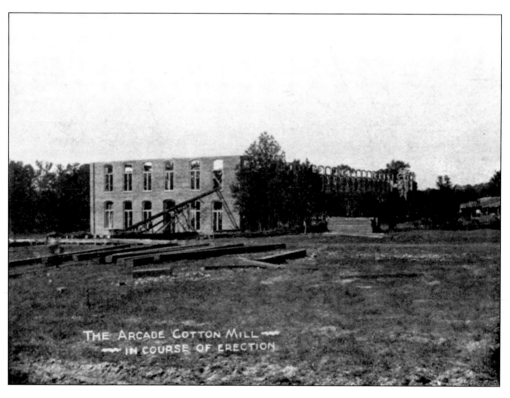

Two

1900–1930

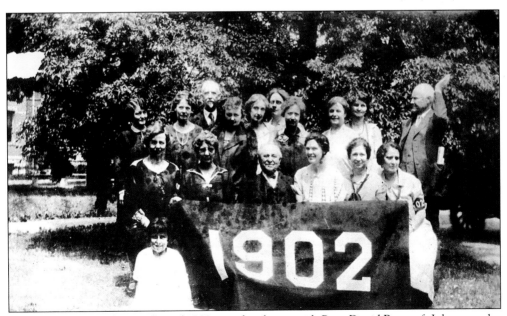

Students from Winthrop's class of 1902 pose for photos with Pres. David Bancroft Johnson, who is seated in the middle of the group.

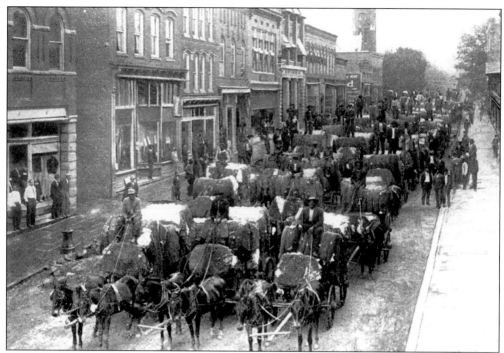

Rock Hill was bustling with agricultural activity in the early 20th century, as this photo shows. Farmers are bringing their cotton crops to town to sell.

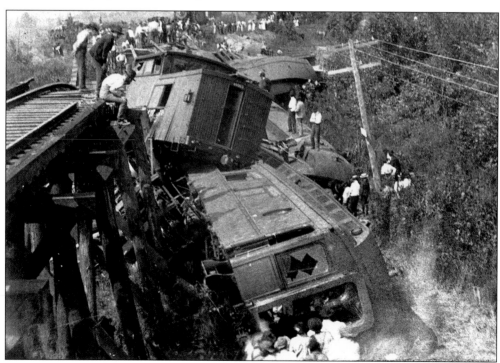

This interesting photo from the York County Library is believed to depict a local train wreck that happened in 1904.

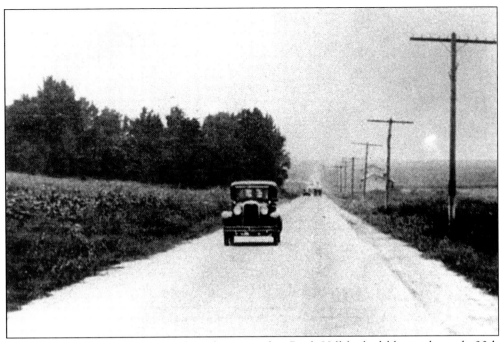

This photograph provides a nostalgic glance at what Rock Hill looked like in the early 20th century. The car is traveling on a recently cemented Cherry Road just beyond what is today The Commons shopping area.

As this postcard shows, Rock Hill leaders were creative in the 20th century attracting tourists to our fair city.

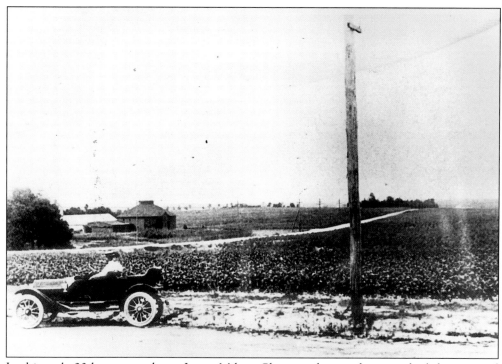

In this early 20th century photo, James Milton Cherry is driving the car, which has stopped where the intersection of Cherry Road and Charlotte Avenue are now. The area across the street, which was part of his large 1,500-acre farm, would later be developed into the Beaty Mall, now the Commons.

At the turn of the 20th century, Sam Jones Tabernacle was a non-denominational meeting place that was located at the corner of Caldwell and Main.

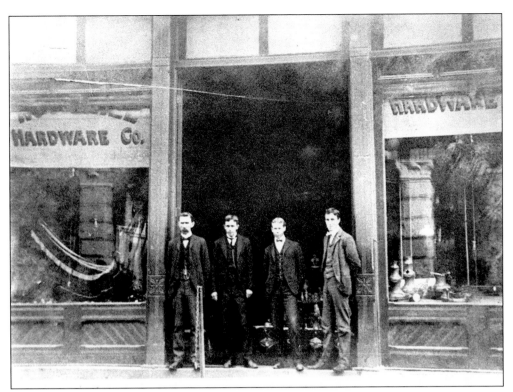

The owners of Rock Hill Hardware Store pose for a photo sometime between 1900 and 1905. From left to right are John White, W.L. Barron, J. Thorn Neely, and R.E. Barron. The Barron brothers were owners while White and Neely were employees. Majority stockholders A.R. Smith and John Gelzer organized Rock Hill Hardware on July 4, 1894. By 1907 all of the stock was in the hands of the Barrons.

"Experts" of the Southland

This postcard of young African Americans picking cotton around 1908 was titled "Experts of the Southland." Cotton dominated the local and state economies into the 20th century. In fact, since the coming of the railway, Rock Hill had become a shipping point for cotton.

31

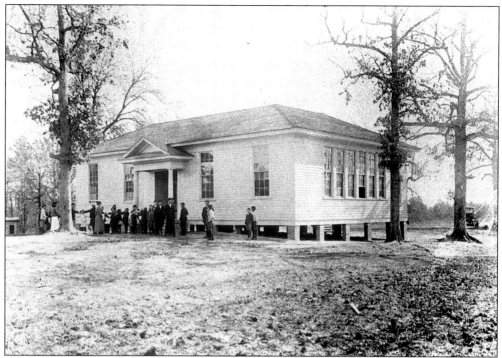

Students from the Catawba Military Academy Cadet Corp appear in this May 10, 1906 photograph. The school was originally started in 1891 as the Rock Hill Presbyterian High School by the First Presbyterian Church in Rock Hill. The second site was built on the present-day Winthrop University campus. When the school became the Catawba Military Academy is not known exactly. By 1907 the school had closed. In 1910 the property was bought by Winthrop University to create a model school for training teachers. That became the Winthrop Training School.

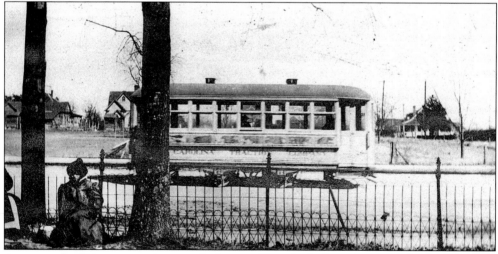

A rare, early 20th-century photograph shows a Catawba Indian sitting inside the Winthrop campus gate selling pottery. In 1912 the old mule-drawn streetcar, as seen in the background, was replaced by a modern storage battery car system. The City Street Railway was discontinued during World War I.

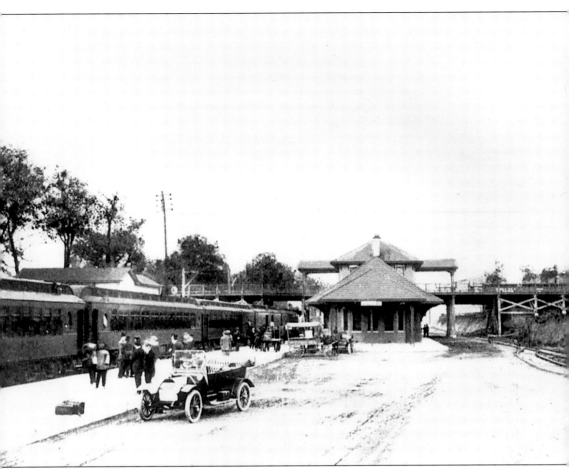

The local Southern Depot is pictured above as it looked in the early 20th century.

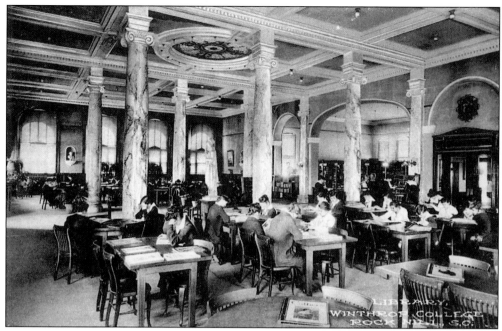

The Carnegie Library at Winthrop was a busy place in 1908, three years after its construction. Winthrop's original library was located on the second floor of Tillman Hall, but by 1904 the holdings had increased to more than 54,000 volumes and additional space was needed. Money for a second library came from philanthropist Andrew Carnegie, who gave $30,000 for the construction of what is now the Rutledge Building.

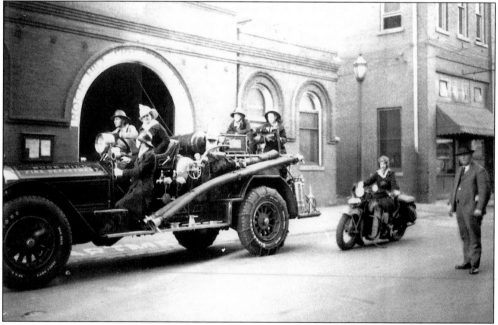

The Rock Hill Fire Department is photographed above about 1909. The fire department was first organized in 1869 as the Hook and Ladder Company. Membership was voluntary and a certain amount of social prestige went with it.

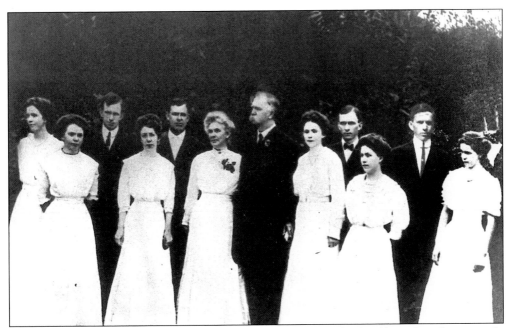

The Wilson family gathers in Rock Hill in 1911 at their home, which still stands and is currently being used by the Catholic church as the Oratory. William Blackburn Wilson was a prominent Rock Hill attorney and president of Old Rock Hill Land and Town Site Company, which was formed in 1890 to develop a 200-acre tract of land known as Oakland Heights. From left to right are Margaret, Loulie, William, Fanny, Blackburn III, Isabella (Mrs. W. Blackburn) Wilson II, Blackburn II, Arrah Belle, Oscar, Minnie, York, and Mary.

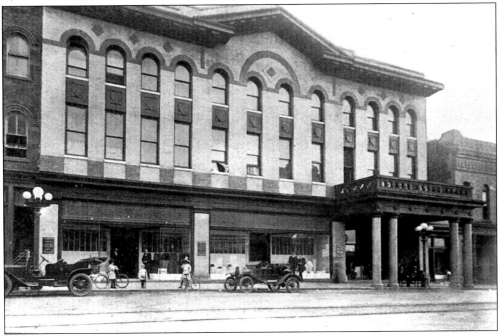

Located at 106 East Main Street, the Carolina Hotel was a popular stopping place for tourists in the early 20th century.

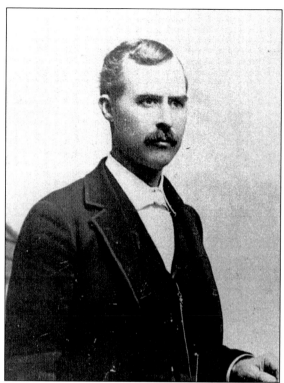

Mr. Edwin Ladson Barnes and his wife Mrs. Mary Sanders Barnes are pictured left and below. The Barnes acquired the Rock Hill Telephone Company from Paul Workman in March 1912. Within two years of their family's purchase of the business, usage increased so rapidly that to handle it a 1,000 wire cable was laid under Main Street. At that time, the company was located on Elk Avenue. Today, the company is known as Comporium Communications.

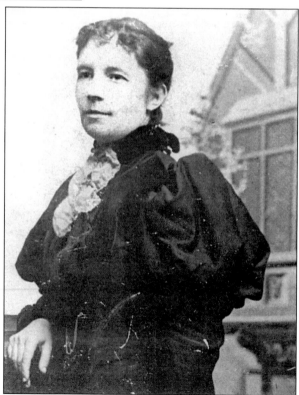

Mrs. Barnes was the matriarch of the family that has provided Rock Hill with leadership in religious, civic, and business affairs for four generations.

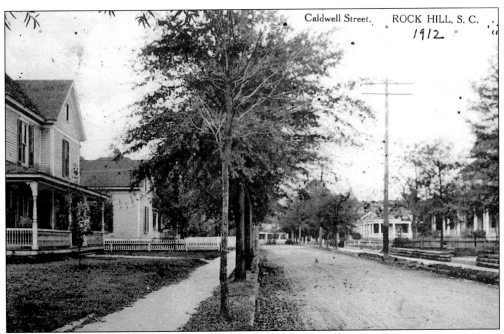

Caldwell Street is pictured above as it looked in a 1912 postcard.

As this ad shows Efird's Department Store at 116–118 East Main Street was a popular shopping destination for Rock Hillians in the early 20th century.

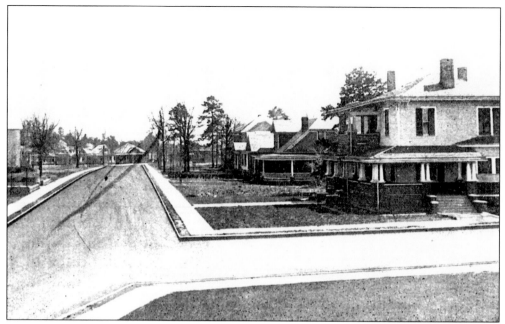

This is a view of a new residential section known as Woodland Park, which James Spratt White developed. This scene shows Saluda and Marion Streets. They had the first cement-block sidewalks in town.

This is a view of Oakland Avenue around 1912. At the time the tree-lined street with the stately homes was one of South Carolina's most prestigious neighborhoods.

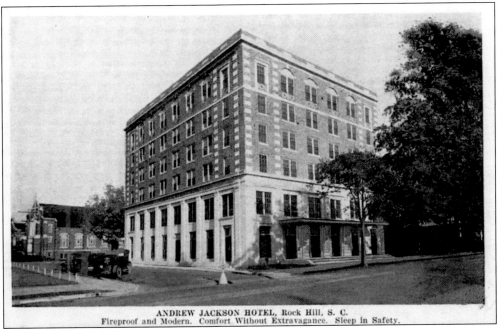

ANDREW JACKSON HOTEL, Rock Hill, S. C.
Fireproof and Modern. Comfort Without Extravagance. Sleep in Safety.

Pictured above is a postcard view of the Andrew Jackson Hotel at 223 East Main Street, as it looked in 1912. The hotel was described in an advertisement as "fireproof and modern. Comfort without extravagance. Sleep in safety."

This photograph provides a 1912 view of the Fennell Infirmary (also called Fennell Hospital), which was opened in 1909. Private clinics and hospitals served the Rock Hill community prior to the opening of the York County Hospital on May 15, 1940.

Alfalfa is ready to be stacked on the plantation of James Milton Cherry. At the time (about 1912), Mr. Cherry was president of the Rock Hill Alfalfa Growers' Association. Known locally as the "Alfalfa King," he was a strong proponent of using alfalfa to enrich the soil and improve farming.

Winthrop's class of 1913 poses for a photo.

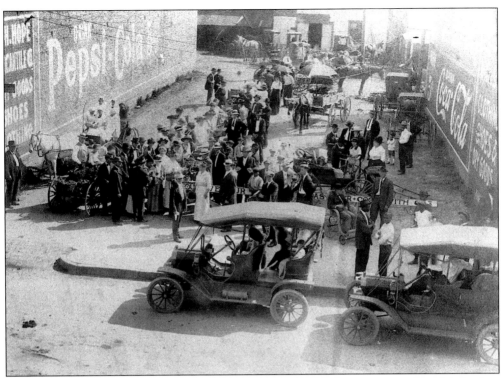

Residents get ready for the first market day on the Woolworth lot in May 1915.

J.C. Cauthen was president of the Rock Hill Chamber of Commerce in 1918. Affectionately known as "Claud," he came to Rock Hill from Kershaw County in 1901. At the time of this photo, he was president and treasurer of the Syleecau Manufacturing Company—one of the largest wholesale and retail lumber concerns in our part of the state.

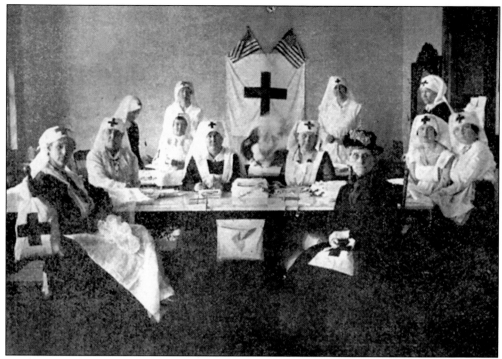

Members of the local Red Cross are pictured in 1918. The caption accompanying the photo in the Rock Hill Magazine read: "Each member a star—Each star a member."

This photo shows the employees of J.C. Hardin & Company in 1919. The photo shows the building owned by the Anderson Motor Company. The three key people in the development of what became the Rock Hill Body Company are at the far right, from left to right, F.S. McFadden, the sales manager and long time employee who worked at the company until his death in 1976; Miss Mabel Stultz, who worked at the company until her retirement in 1962; and James C. Hardin, who founded the company in 1915.

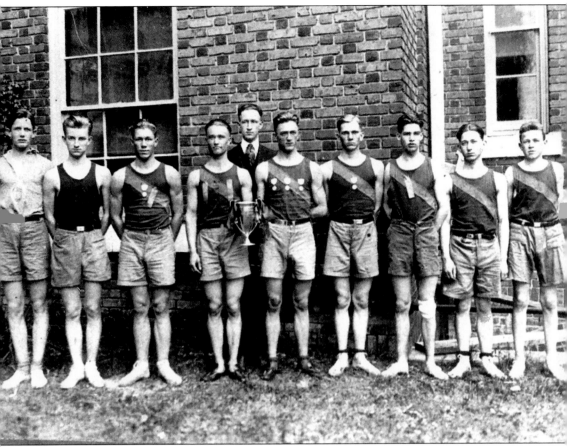

The 1921 Winthrop Training School track team is pictured here in 1921. The team is most likely standing in front of the Withers Building where the school was located. From left to right are Mack Coker, Cecil Mauldin, William Steele, Henry Whisenant, Barron Nichols (coach), Howard Clinton, Jack Fewell, Will Fewell, Bruce Fewell, and William Bailey.

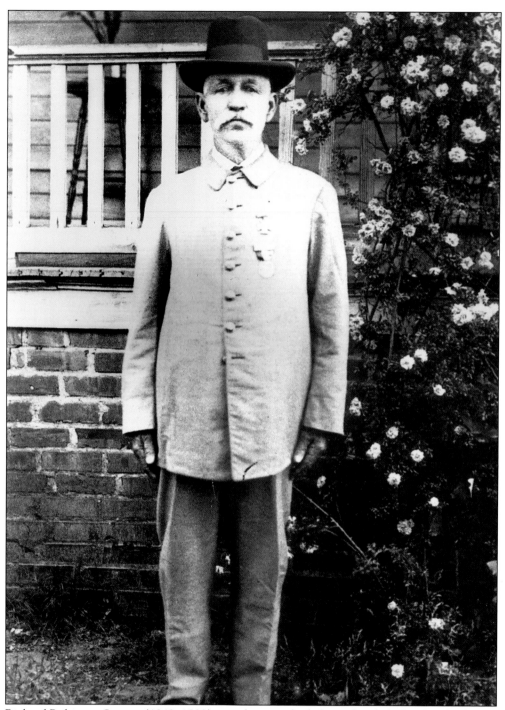

Richard Robinson Starnes (1842–1922) was photographed above shortly before his death. Mr. Starnes served in the Civil War with Company C, First North Carolina Calvary, first under Gen. Jeb Stuart and then under Gen. Wade Hampton. He was captured in 1863 and remained a prisoner of war at Fort Delaware prison until Gen. Robert. E. Lee's surrender. Mr. Starnes returned to Rock Hill after the war and worked as a farmer.

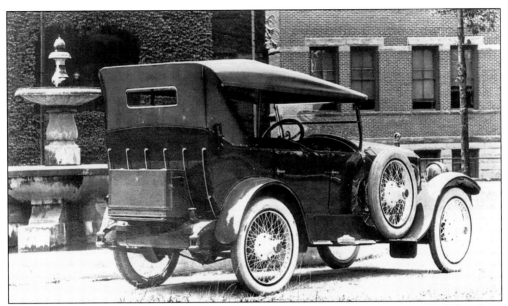

An Anderson Touring car sits on the grounds of Winthrop University in 1922. John Gary Anderson, an entrepreneur and innovator who left his mark on the American automobile industry, manufactured Rock Hill's famous Anderson car. Anderson sold his car in the 1910s and 1920s. After going bankrupt, the Anderson Motor Company's buildings and plant were sold to M. Lowenstein and Company in 1929.

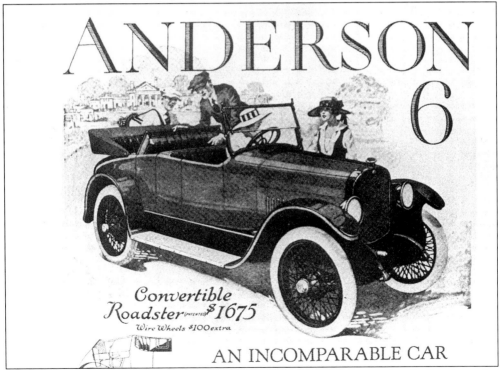

An advertisement for the Anderson 6 appears above. Mr. Anderson was ahead of his day in his use of advertising.

Rock Hill, S. C.

PRO BONO PUBLICO

PREFACE

Rock Hill, situated at the foothills of the Blue Ridge in the Piedmont Section, 670 ft. above sea level, is the largest city in York County, one of the richest rural counties of South Carolina.

With a community population of 17,000, Rock Hill, "the Gateway to the Fertile Catawba Valley," is in the center of a large hydro-electrical development and is ideal for home and business.

Rock Hill has eight textile plants, two yarn mills and numerous smaller industries that furnish employment to more than 3,000 operatives with an annual pay roll of approximately $3,000,000.00.

Rock Hill's city school system ranks among the best in the country. There are eight public schools for white and four for colored, with an enrollment of 4,741.

Winthrop, the State College for Women, with an enrollment of 1,572, is regarded as one of the most valuable assets of the social and business life of the city. No institution of higher learning surpasses Winthrop in the splendid combination of cultural and vocational training provided.

Specific information regarding Rock Hill and surrounding territory will be cheerfully furnished by the

ROCK HILL CHAMBER OF COMMERCE,
Rock Hill, S. C.

When Writing Advertisers Please Mention Directory

This advertisement, which appeared in the 1926 Rock Hill City Directory, touted the assets of the young growing town of Rock Hill.

The old Arcade Victory No. 3 Mill, which was built in 1900 and abandoned in the 1920s, is seen above. James C. Hardin Sr. purchased the building around 1937 for his business, the Rock Hill Body Company.

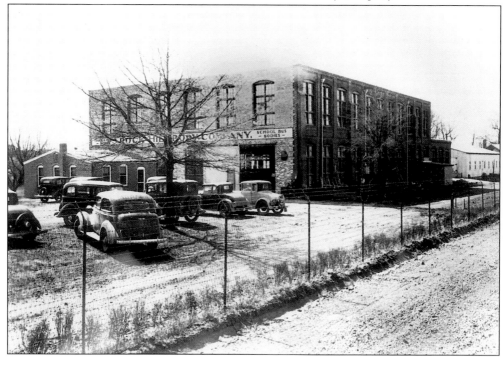

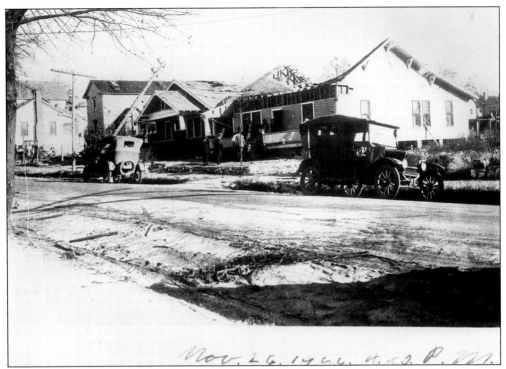

Nov. 26, 1926. 4:30 P. M.

This photo, which was dated November 26, 1926, shows the north side of Moore Street between Hampton and Green. The two-story house facing Hampton was the home of Dr. "Berkie" Patrick.

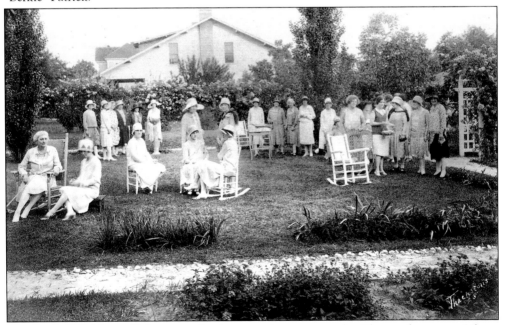

The Rock Hill Music Club is seen having a garden party at the Thomas home on Aiken Avenue in 1926. The Rock Hill Music Club was founded in 1914 and has enriched our city's cultural life ever since.

W.J. Roddey, a leading mover and shaker in Rock Hill's early development, is pictured to the left. He served nearly 50 years on the Winthrop Board of Trustees.

The J.L. Phillips Drug Company, a Rexall store, was serving Rock Hill as early as 1928.

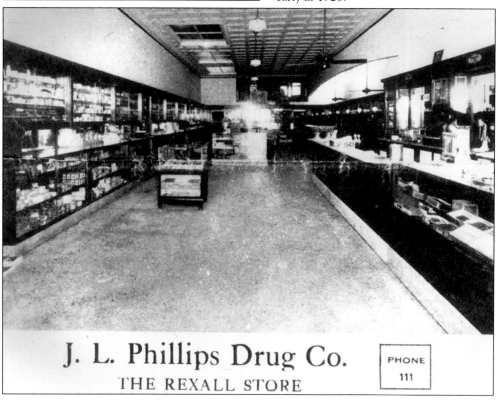

J. L. Phillips Drug Co.
THE REXALL STORE

PHONE
111

This advertisement appeared in a 1928 *Evening Herald* promotion insert.

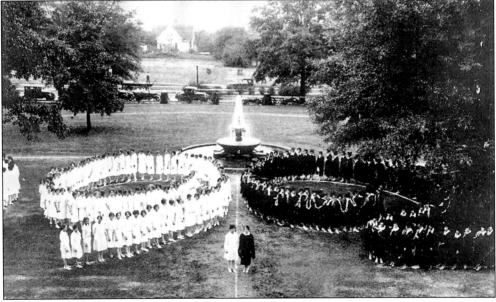

The Daisy Chain procession was captured in action before the Fountain at Winthrop University in 1929. The Daisy Chain tradition began in 1903. As first staged at Winthrop, the ceremony consisted of members of the graduating class and their junior sisters. Following commencement, the young women joined a procession across the front campus halting at the fountain to sing. The seniors placed their mortarboards on the heads of the juniors, thus symbolizing their succession to senior status.

Erwin Carothers, lawyer, was mayor of Rock Hill in 1930. This photo was taken in the Citizen's Bank Building.

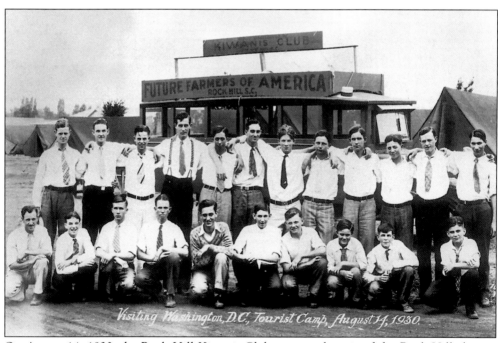

On August 14, 1930, the Rock Hill Kiwanis Club sponsored a trip of the Rock Hill chapter of the Future Farmers of America to Washington, D.C. As the club's records in the Winthrop Archives reveal, the local Kiwanis Club was chartered in 1920.

Three

1930–1945

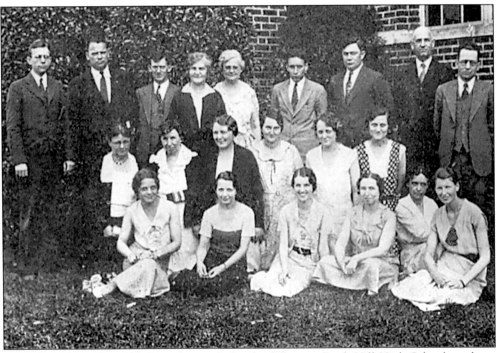

This photo from the 1932 *Catawban* includes the following Rock Hill High School teachers, pictured from left to right: (front row) Nida DePass (French), Gladys Mullinax (Latin), M.D. Ward (English), W.J. Cherry (math), and Edna Russell (biology); (middle row) Eva M. White (English) Cammie Roddey (English), Ruth Williams (math), Ellie Baugh (English), Frances Williams (home economics), and Arabelle Gill (math); (back row) Allen Hurd (history), E.L. Wright (history, coach), D.F. Kirven (physics and chemistry), Mary Marshall (commercial subjects), Roberta Wardlaw (math and civics), W.M. Kennedy (math), Jesse Barbour (history), R.C. Burts (superintendent), W.C. Sullivan (principal), C.W. Coons (manual arts).

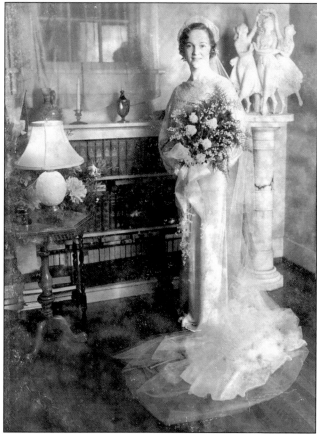

James P. Kinard (1864–1951), Winthrop's Dean of the College, succeeded David Bancroft Johnson as president in 1929. Kinard had graduated from the Citadel in 1886 as a member of the first class to graduate from the school after the Civil War and went on to receive his Ph.D. from Johns Hopkins University. Dr. Kinard came to Winthrop as a professor of English in 1895. He served ably as Winthrop's president until 1934.

Louise Thomas Miller (1904–1985) is pictured as she looked before her wedding to Joseph Roddey Miller on August 22, 1934. Ms. Miller headed Thomas Tours from 1945 to 1970.

Jessie Huey Laurence was a prominent local educator, writer, businesswoman, and clubwoman. She was president of the Winthrop College Alumnae Association (1933–1935), founder and first president of the Woman's Council for the Common Good (1935–1938), and founder and first president of the Women's Economic Council (1941–1943).

Rock Hill Drum and Bugle Corp leads a parade of the National Band Association on Main Street on June 18, 1937.

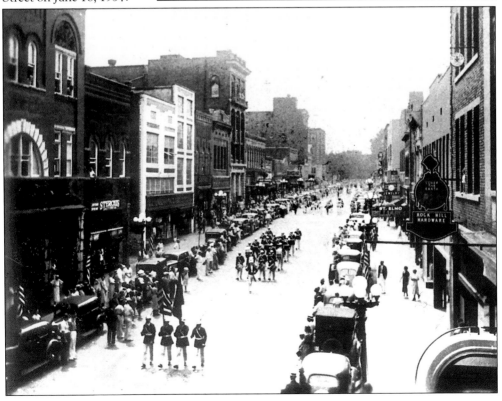

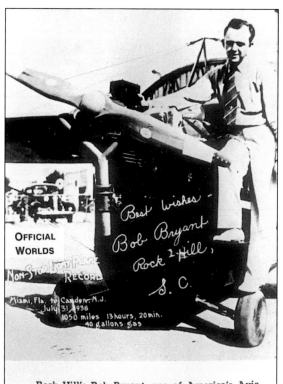

Bob Bryant, a prominent Rock Hill citizen and one of America's aviation pioneers, is pictured holding the Federation Aeronautique International Barograph at the end of his world-record breaking flight in 1938. Mr. Bryant flew non-stop from Miami to Camden, New Jersey, in 13 hours and 20 minutes to set the light plane record. His plane, an Aeronca C–3, weighed less than 520 pounds.

Rock Hill's Bob Bryant, one of America's Aviation Pioneers, is pictured holding the Federation Aeronautique International baragraph at the end of his world's record breaking flight in 1938.

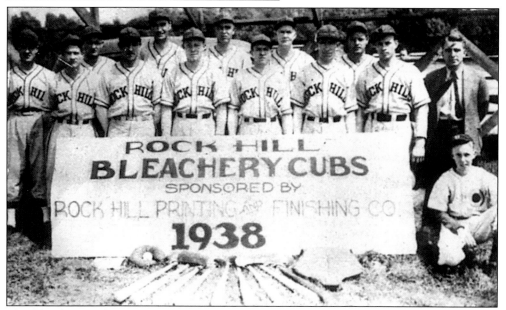

The Bleachery Cubs were one of the winningest semi-pro baseball teams in Rock Hill. The team for 1938 is shown here with their business manager, John Martin.

54

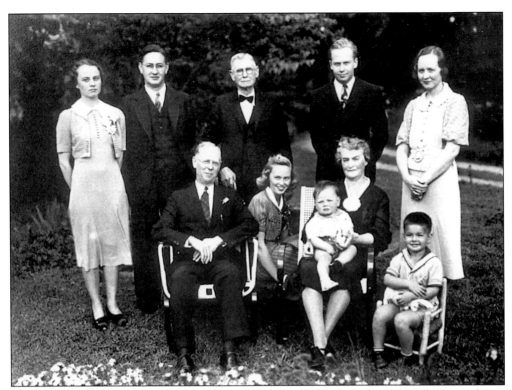

This late 1930s photo shows four generations of the Neely family at the Oakland Avenue home of James Thornwell Neely Sr. From left to right are the following: (seated) James Thornwell Neely Sr., Mary Sadler Neely, Lillie Earle Sadler Neely (holding James Neely Townsend), and George Elliott Townsend Jr.; (standing) Caroline Craighead Neely Burgin, George Elliott Townsend Sr., John Josiah Richards Bishop Neely, James Thornwell Neely, Lillie Earle Sadler Neely Townsend. At the time of this photo, James Thornwell Neely Sr. owned the oldest established automobile dealership in Rock Hill as well as two farms that produced cotton.

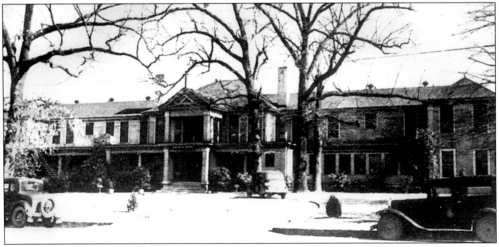

St. Phillips Mercy Hospital on Confederate is pictured here as it looked in late 1930s. The Sisters of the Order of St. Francis owned and operated the 60-bed hospital.

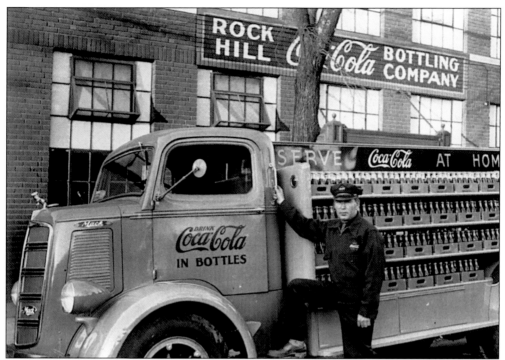

Pat Strait, route driver for the Coca Cola bottling company, poses for a photo in the late 1930s. Mr. Strait later became the company's head of production. The plant was located at the intersection of White Street and Caldwell across from the Episcopal Church from 1925 to 1941. The plant was later moved to its current location on the corner of Cherry Road and York Avenue.

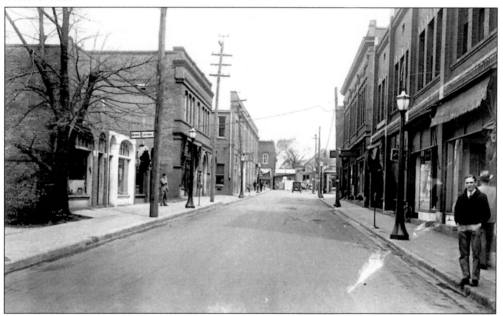

This postcard provides a view of Hampton Street between Main and Black Streets. Wallace Bryant is on the right facing the camera.

Shelton Phelps, president of Winthrop from 1934 to 1943, and Eleanor Roosevelt, wife of Pres. Franklin D. Roosevelt, are seen in the photo to the right. Mrs. Roosevelt spoke at Winthrop on April 27, 1940.

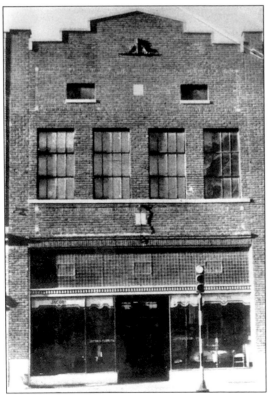

The front of Jacobs Furniture Store was photographed about 1940. Located on Main Street, the store was Rock Hill's largest and most progressive furniture and household goods dealer. R.H. Jacobs owned and managed the store.

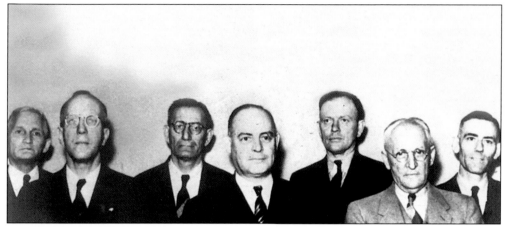

In 1940, Rock Hill had a commissioner-manager form of government that consisted of a mayor, four commissioners, and a city manager. Shown above, from left to right, are City Manager T.C. Marshall, Mayor Pro Tem J.C. Hardin, commissioner J.J. Rauch, Mayor Erwin Carothers, Commissioner J.P. Poag, Commissioner P.C. Blackman, and Clerk-Treasurer Ben R. Neely.

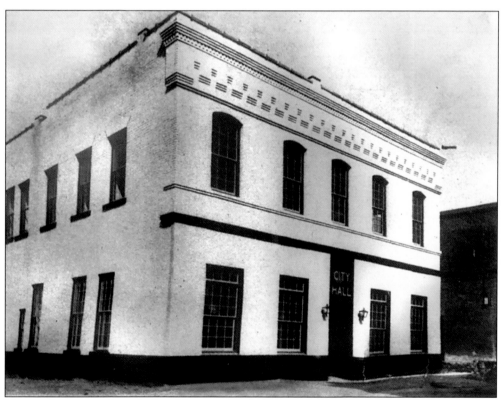

The newly renovated city hall on Hampton Street houses the city's administrative departments. The Chamber of Commerce was located on the second floor. This picture was taken c. 1940.

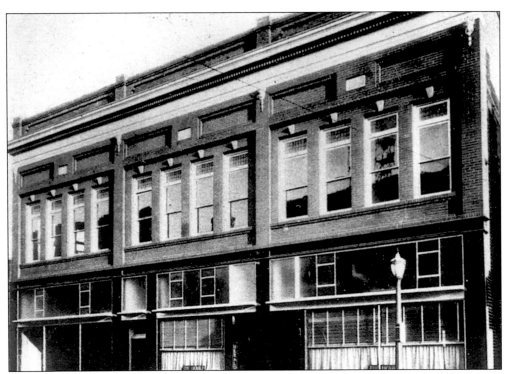

The building housing *The Herald* newspaper and Record Printing Company is pictured here as it looked in the late 1930s. The building was located on Hampton Street, just off Main.

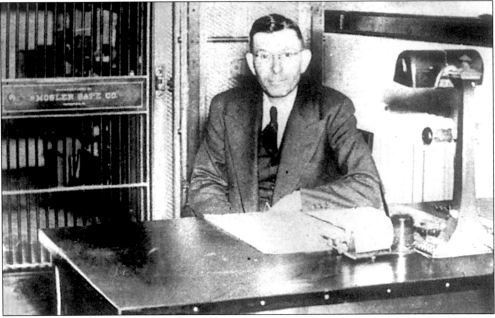

P.W. Spencer, secretary and treasurer of the Mechanics Federal Savings and Loan Association, is pictured above in this 1940 photo. Mr. Spencer had held the position since 1913. For years, Spencer also served as secretary and treasurer of the South Carolina Building and Loan League and Director of the Federal Home Loan Bank, Winston Salem, North Carolina.

Jac Fienberg, Hosiery Mill Inc., one of the town's leading manufacturing enterprises, is pictured above, as it looked about 1940. The plant used 44 machines to manufacture an annual output of more than 2 million pairs of ladies fine fill fashion hose, which was sold all over the area. David R. Baer was the company's manager, and it employed 260 persons. Baer bought the company and operated it until the mid-1970s.

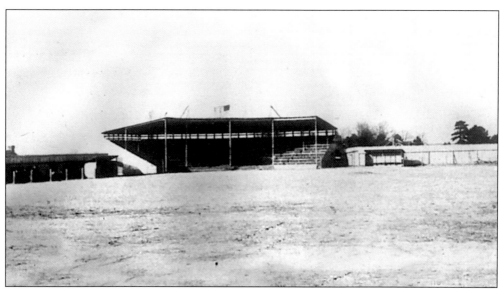

The grandstand and bleachers at the Highland Park baseball grounds are pictured here about 1940. This was the only enclosed athletic field in Rock Hill at that time.

As part of the country's World War II efforts, these signs were posted at the Rock Hill Printing and Finishing Company on White Street.

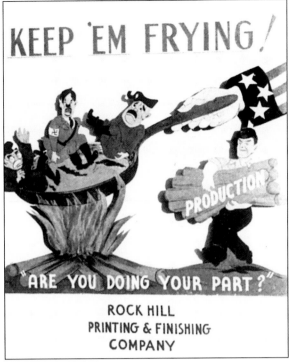

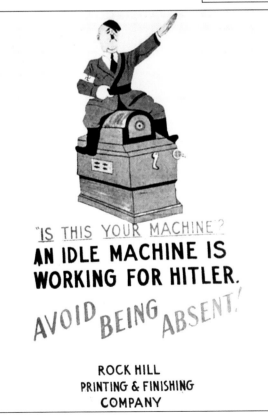

The Rock Hill Printing and Finishing Company began operations in the old Anderson Car Company Plant in 1929. A.O. Joslin was the first manager of the so-called "Bleachery." He was succeeded by Walter T. Jenkins and in 1947 by William H. Grier. By the mid-1950s, the Bleachery employed as many as 5,000 people. The Bleachery arguably had more impact on our community than any other single company.

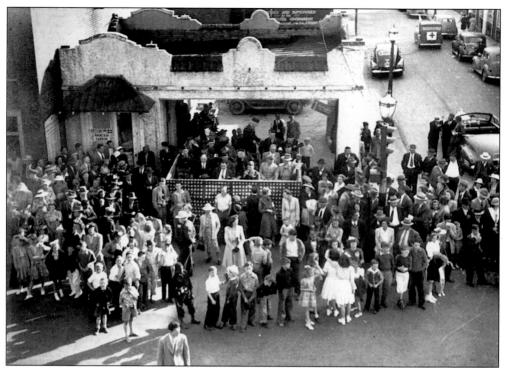

Democratic governor Richard Manning Jeffries visits Rock Hill on April 2, 1943, during the last year of his term in office.

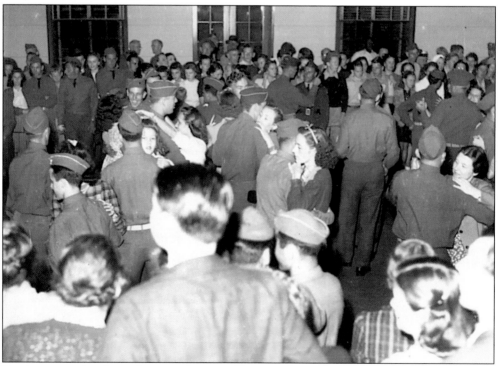

Service men enjoy themselves at a dance on Hampton Street during World War II.

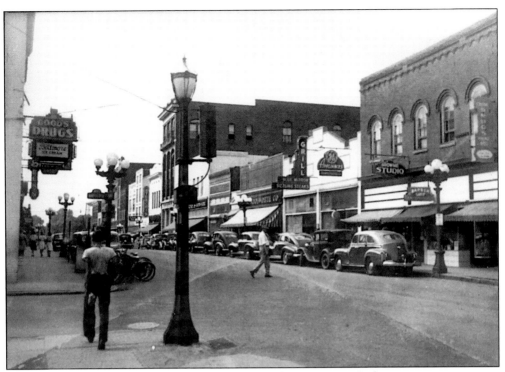

Downtown Rock Hill is seen above looking west in this May 8, 1943 photo.

Ed Rauton is seen enjoying a quiet moment. Mr. Rauton served as an air raid warden during World War II. Ed Rauton and his family came to Rock Hill in 1934, and for the next 43 years, they operated the Brownie Studio. This photographic was originally located on Hampton Street and then the family moved it to Main Street.

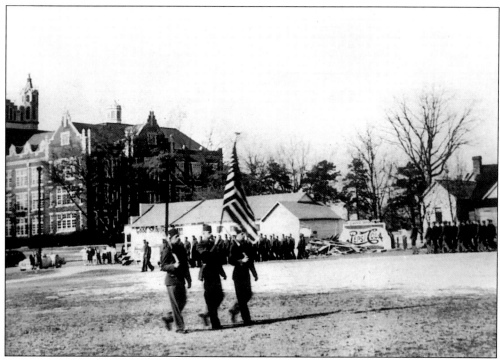

Aviation cadets from the Army Air Force's 41st College Training Detachment march in review in April 1943 on the drill field, which was on the site of the present-day Dinkins Student Building. The Withers and Good Buildings are in the background. The Civilian Pilot Training Program, which ran from 1942 to 1944 and was based at Winthrop, was designed to prepare cadets both physically and mentally for pre-flight and flight school training in other parts of the country.

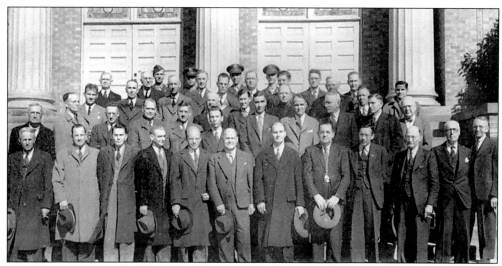

Members of the Rock Hill Rotary Club are pictured above as they attended the November 11, 1943 meeting. The service organization was founded in 1918. The group is standing in front of the First Baptist Church on Main Street. This meeting was probably held at the Andrew Jackson Hotel across the street.

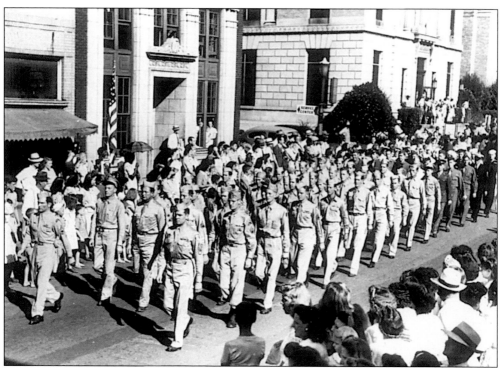

Pictured above are soldiers marching in downtown Rock Hill during World War II.

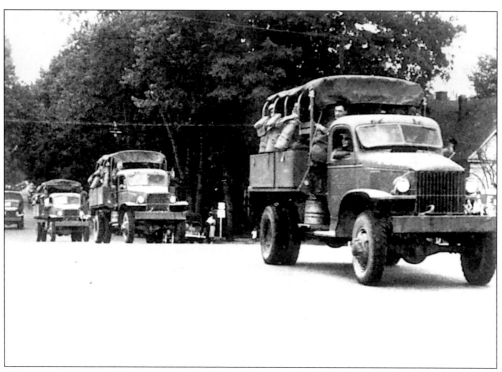

An army convoy rumbles across the Oakland Bridge during World War II.

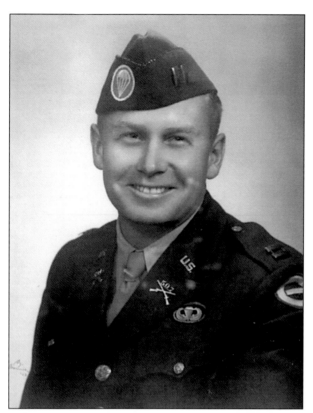

James Thornwell Neely Jr. (1912–1999) is pictured here as he looked in 1944, prior to going overseas to fight in the European Theater of World War II as a paratrooper. Mr. Neely later became president of Neely Motor Company, which was located on 125 South Oakland Avenue, where Waldrop Supply is located today.

In 1944, Mrs. D.B. Johnson, wife of Winthrop's founder and first president David Bancroft Johnson, went to Brunswick, Georgia, to christen the liberty ship, the *S.S. David B. Johnson*. Named for outstanding Americans, liberty ships were special cargo ships that delivered badly needed supplies to the allies.

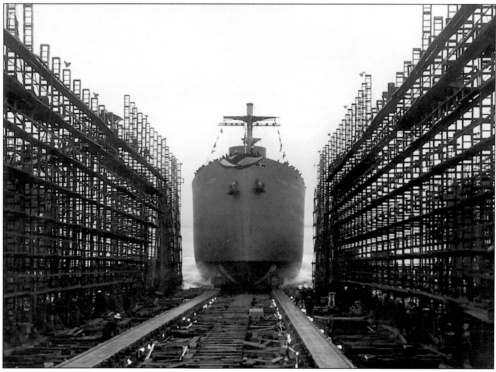

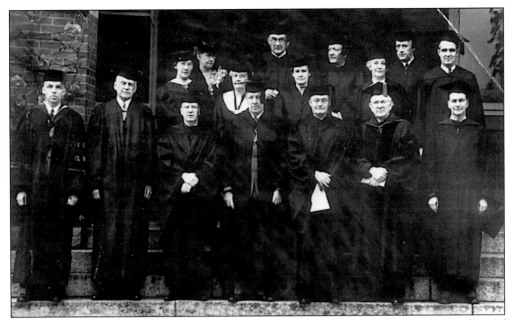

The presidential party for the inauguration of Pres. Henry R Sims, the fourth president of Winthrop who served until 1959, is seen above. From left to right are the following: (first row) Winthrop dean Mowat G. Fraser, Judge Arthur L. Gaston, Pres. Henry R. Sims, John Temple Graves, South Carolina governor Ransome J. Williams, Bishop Claire Purcell, and the Reverend A.W. Hawkes; (second row) Mrs. N. Gist Gee, Mrs B.L. Tilghman, Mrs. Louise Y. Earle, Mrs. P.B. Hendrix, and Mr. John T. Roddey; and (back row) Mrs. D.B. Johnson, Mrs. J.M. Hope, Mr. C.L. Cobb, and Mrs. John G. Dinkins.

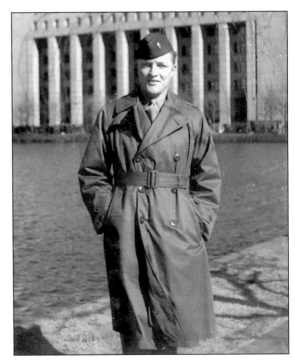

Bobby Thomas is pictured above in occupied Japan at the close of World War II. Mr. Thomas grew up at his family's home at 620 Aiken Avenue. As the first house on the block, the Thomas family got to choose the number for their house. The train arrived in Rock Hill at 6:20.

ASSOCIATED PRESS SERVICE

THE EVEN

The Weather.
Cloudiness and mild temperatures today and tonight. Tuesday partly cloudy and warm.

VOL. 69. NO. 210.

ROCK HILL, S. C., MOND.

AMERICANS FIC

HERR GOEBBELS DIDN'T PROMISE THIS—Herr Goebbels promised the German people that many towns would be taken in their hour of triumph, but he forgot to promise them that this also could happen. An Allied 57mm anti-tank gun crew uses the main trolley stop in Rheydt, the Doctor's home town, as cover as they continue to advance. (U. S. Signal Corps Radiotelephoto.) (NEA Telephoto.)

Filipino U.
Clear Prov
Of Jap Tro

American Troop
Deeper Into Nor
Luzon Area

By FRED HAMPS

Manila (AP)—American pushed deeper today into t tains of northern Luzon, headquarters stronghold ese Gen. Tomoyuki Yam Gen. Douglas MacArthur that Filipino guerrillas ha one entire northern pro Nipponese troops.

Other Americans over last Japanese resistance i continued their eastward to secure the city's wate area and occupied two m ippine islands.

MacArthur's communiqu units of the 25th and 32nd of Maj. Gen. Innis P. Sw corps had made new gair northern mountains along lete Pass road, the Vil trail and the Ambayaban

These spearheads were south of Baguio, the summer capital. Yamashi Tiger" conqueror of Singa reported weeks ago to ha drawn there to direct stand" defense of the Phil

Other First corps units I engaging the Japanese in the vicinity of Rosario, or 30 miles southwest of

Baffle Japs

REDS SHELLING STETTIN SECTOR

Berlin Says Russians Have Taken Fortress Town of Stargard

BY RICHARD KASISCHKE

London, (AP)—Marshal Gregory Zhukov's big guns have begun shelling—

WORLD BULLETINS

By The Associated Press

Washington—The justice department gave a thumbs-down opinion today on single-company operation of America's international air transportation. The department said it is opposed also to surface carriers, such as steamship companies, owning or controlling international airline companies.

J. C. HAYES, 60, TAKEN BY DEATH

Funeral Services To Be Held Tomorrow At 3 At Ebenezer Church

John Calvin Hayes, Sr., 60, sergeant on the Rock Hill police force, died in York county hospital about 10:45 o'clock this morning following

These headlines of the Rock Hill *Evening Herald* newspaper show that the U.S. is well on its

NG HERALD

The Market

Local Spots 22

NOON, MARCH 5, 1945 FULL NEA SERVICE 8 PAGES TODAY—PRICE 5c.

HT IN COLOGNE

FIRST PHOTO OF DUESSELDORF—This photo, the first radio-telephoto to be transmitted direct from the battlefield shows the buildings and bridges of Duesseldorf across the Rhine River as American infantrymen of the U. S. Ninth Army reach the opposite bank.—NEA Telephoto.

Tank Force Break Through To Storm City

Fourth Largest Metropolis Is Scene Of Bitter Fighting

..Paris (AP) — American tanks and infantry stormed into Cologne today in a final powerful attack on the great Rhineland metropolis, and slowly fought toward the heart of Germany's fourth largest city.

The Germans said today the Rhine bridges at Duisburg had been destroyed, leaving crossings only at Wesel and Cologne on the lower reaches of the river.

Smoke rolled up from fires and explosions set by bursting American shells. The Doughboys inside Cologne caught flashing glimpses through the pall of the slender 51-foot tower of the 13th Century Cathedral. Artillery and troops had been ordered to hold their fire away from the magnificent structure.

At 9 a. m., Lt. Col. John Woborn of Southern Pines, N. C., had his troops fighting at Longerich, the northern end of the sprawling railway yards of Cologne, one of the greatest rail centers in Europe, and the chief traffic center for western Germany.

Resistance from remnants of a tank and volksgrenadier division

Red Cross Fund Reaches $17,000

VANS HARRILL IES IN ACTION

War Department Con-

Campaign Contributions Now Short Of Goal By $8,725

Contributions for the Red Cross War Fund drive reached $17,000 today, W. H. Grier, chairman, report-

CAROTHERS IS URGED FOR POST

"Citizens Committee" Wires Legislature On Trustee Election

A "citizens committee" of Rock Hill has asked the support of every member of the South Carolina legislature for Mayor Erwin Carothers

way to winning World War II.

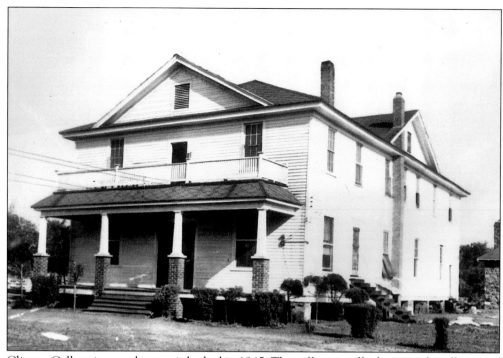

Clinton College is seen above as it looked in 1945. The college is still educating the offspring of local residents more than 55 years later.

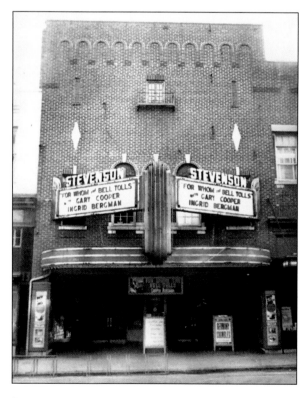

The old Stevenson Theater at 109 East Main Street is pictured to the left, as it looked on March 3, 1945.

Four

1945–1960

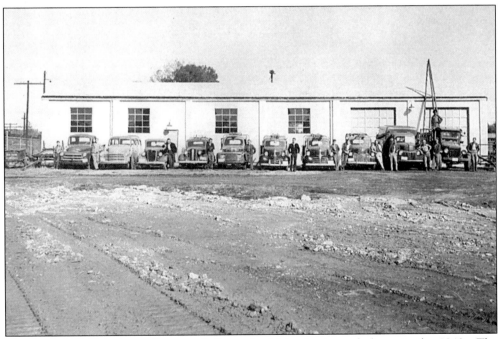

The Rock Hill Telephone Company's fleet of vehicles is pictured above in the 1940s. The company has grown to become Comporium Communications, which provides telephone, cable TV, internet, security, wireless, and other communications services to Rock Hill and the surrounding region.

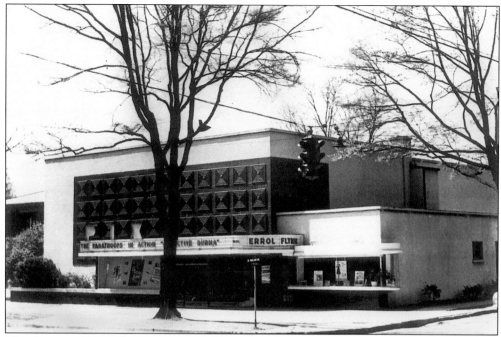

The photograph provides a 1946 view of the Pix Theater on the corner of Oakland Avenue and Wilson Street.

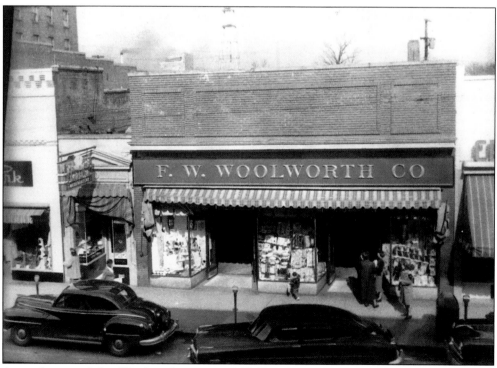

A good view of the Woolworth store at 143 East Main Street in 1949 was captured in this photograph.

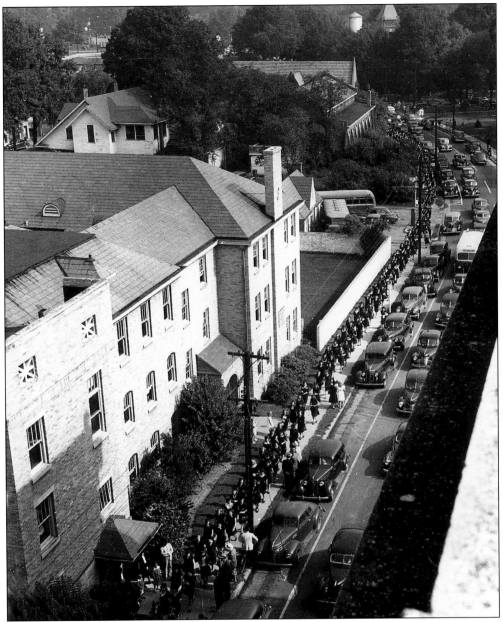

In this 1949 aerial photo, Winthrop students can be seen marching in the school's traditional Blue Line. After Winthrop moved to Rock Hill in 1895, the Blue Line tradition began. Students would dress in their blue uniforms, and led by the president, they would walk down Oakland Avenue. This photo was taken on top of what today is the Guardian Building across from the First Baptist Church.

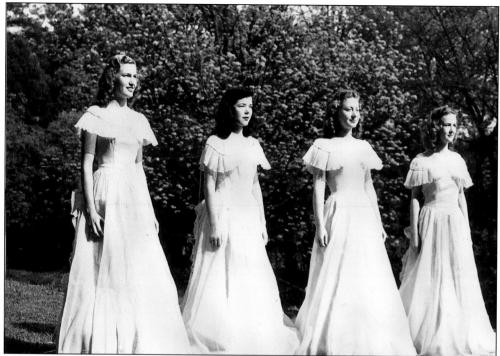

In this 1949 photo we see junior attendants at the court of another Winthrop tradition—May Day. Begun in 1929, May Day was one of Winthrop's most venerable traditions. On the first Saturday in May, hundreds of Winthrop alumni, students, their parents, and townspeople filled the brick tiers of the Amphitheater. The May Day consisted of sixteen handmaidens, four from each class. For many years, May Day was the last big celebration before graduation.

In 1949, The Saturday Afternoon Book Club journeyed to Camden, South Carolina.

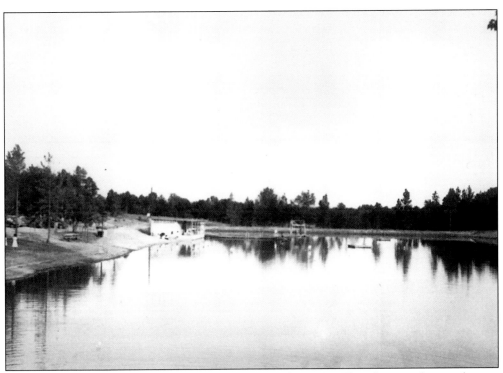

Hollis Lakes was a popular public swimming place in the 1950s. This photograph was taken on May 22, 1950.

The original organizers of the Rock Hill Saddle Horse Association pose for a photo in 1950. From left to right are Ed Allen, Bill White, C. Harris Williams, and Arnold Marshall.

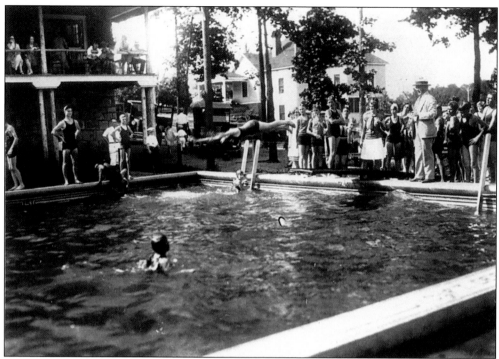

The Confederate Park swimming pool is pictured above. Those identified in the photo include Sarah Workman (white skirt), Alberta Thomas (white dress) second from left, and Hampton Talley, second boy from left.

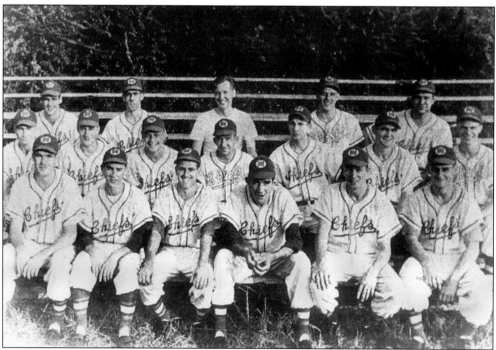

The Rock Hill Chiefs, a minor league professional baseball team, pose for a photo in 1950.

Dusty Rhodes, the New York Giants hero of the 1994 World Series, was the most famous Rock Hill Chief of all. Mr. Rhodes worked for the Rock Hill Printing and Finishing Company (the Bleachery) while playing for the Chiefs. The Giants beat the Cleveland Indians 4-0 in the 1954 World Series. Dusty Rhodes, who played for the Giants from 1952 to 1957, had two key homers.

Leading officers in the Rock Hill Woman's Club confer with Winthrop College Pres. Henry R. Sims in 1951 about an upcoming South Carolina Federation of Women's Club convention. From left to right are (seated) Pres. Henry R. Sims and Mrs. C.M. Kuykendal; (standing) Mrs. Boyd Hull, Mrs. W.P. Sibley, and Miss Bessie Poag.

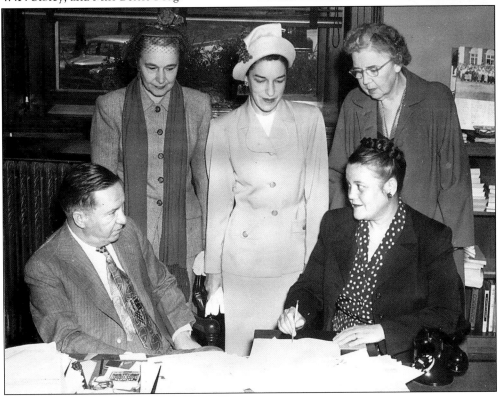

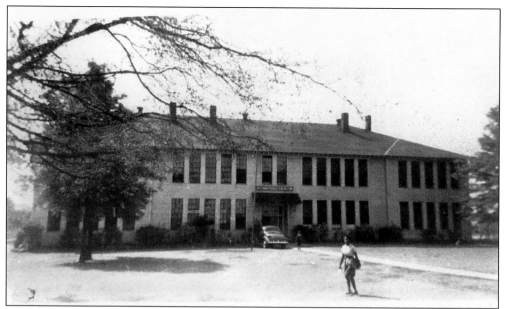

A mid-century view of Emmett Scott School, which educated Rock Hill's young African Americans. The school closed its doors when local schools desegregated in the mid-1970s. Integration began when seven black students were selected to attend Rock Hill High School.

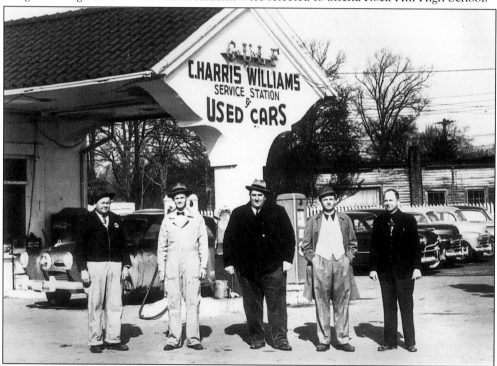

The operators of C. Harris Williams Gulf Service and Used Car Department pose for a photo in the early 1950s. From left to right are W.J. Williams, Leonard Walker, Hugh Finger, Wade Williams, and owner C. Harris Williams. C. Harris Williams (1912–1960) bought the station in the 1930s. It closed in 1992 and is now a Rock Hill landmark.

Pictured above is a photo of Haire's Service Station, which was probably taken around 1950. Built in 1945, the station was owned by Vernon and Jeddie Haire and is located on what is now Highway 161 across from the Armory and Winn Dixie. Today, the building is being used as an auction barn.

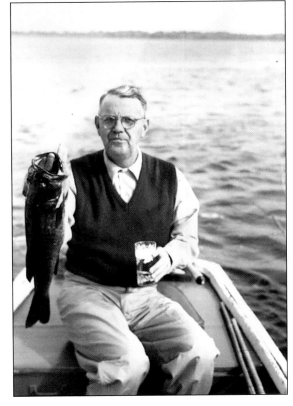

Bill Grier Sr. (1903–1984) goes fishing in this 1951 photograph. Mr. Grier was the president of M. Lowenstein and Sons Finishing Division (formerly Rock Printing and Finishing Company) and a community leader. He was the first person to receive an honorary doctorate from Winthrop University for his work as a Winthrop trustee.

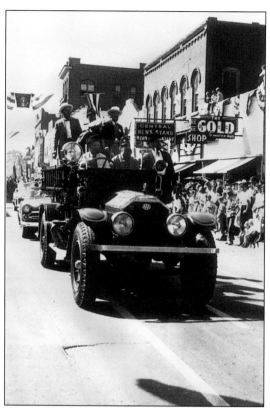

In 1952, Rock Hill celebrated its 100th birthday. This parade through downtown Rock Hill highlighted the celebration.

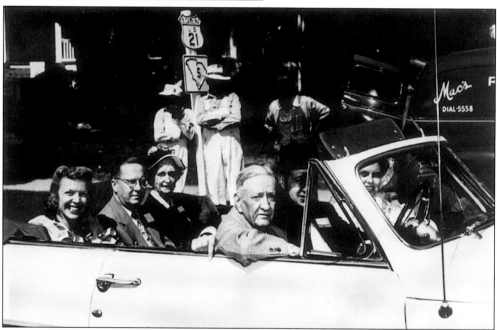

Some prominent Rock Hillians enjoy the parade during the 1952 Rock Hill Centennial. The prominent citizens pictured include Duff Friedman, Henry R. Sims, and Mrs. C.L. Cobb, Charles L. Cobb, Bob Friedman, and driver (unidentified).

A copy of the program commemorating the historic occasion is seen here.

CENTENNIAL CELEBRATION

MAY 4-10, 1952

"People working together, to make their community a better place in which to live and make a living"

PRESENTED UNDER THE AUSPICES OF
THE ROCK HILL CHAMBER OF COMMERCE
Featuring
THE DRAMATIC HISTORICAL SPECTACLE

"ROCK HILL CALVACADE"

SIX DAYS OF FESTIVAL AND FUN

ROCK HILL, SOUTH CAROLINA

EVENTS OF THE SPECIAL DAYS OF CENTENNIAL WEEK

SUNDAY—"FREEDOM OF RELIGION DAY"

9:00 a.m.	Brothers of the Brush and Sisters of the Swish Reception—South Carolina Breakfast Club.
10:00 a.m.	Miss Rock Hill at Roddey Airport.
12:00 noon	Breakfast Club Luncheon.
7:00 p.m.	Shriners' Band
8:00 p.m.	Praise and Worship.

MONDAY—"GOVERNOR AND HOME COMING DAY"

10:00 a.m.	Celebration Opening—Church Bells toll—whistles blow
11:00 a.m.	Registration of Visitors
11:30 a.m.	Governor's Reception—by Brothers of Brush
12:00 noon	Cutting of Birthday Cake—All exhibits open; Governor's Luncheon —Andrew Jackson Hotel; Cedric Foster, Speaker.
2:00 p.m.	Parade
5:00 p.m.	Kangaroo Kourt
8:30 p.m.	Pageant
10:00 p.m.	Fireworks

TUESDAY—"WINTHROP DAY"

10:50 a.m.	Assembly Program—Winthrop Auditorium—John Scott, Editor Time Magazine, Speaker.
3:30 p.m.	Band Concert—Winthrop Amphitheatre.
4:30 p.m.	May Day Program—Winthrop Amphitheatre
8:30 p.m.	Pageant
10:00 p.m.	Fireworks

WEDNESDAY—"MERCHANTS DAY"

11:00 a.m. until 1:00 p.m.	Open House in Stores
2:00 p.m.	Community Picnic—Confederate Park
2:30 p.m.	Games and Contests
5:00 p.m.	Picnic
8:30 p.m.	Pageant
10:00 p.m.	Fireworks

THURSDAY—"BROTHERS OF THE BRUSH AND SISTERS OF THE SWISH DAY"

12:00 noon	Brothers of the Brush Parade
2:00 p.m. until 5:00 p.m.	Kangaroo Kourt
8:30 p.m.	Pageant
9:00 p.m.	Street Dance
10:00 p.m.	Fireworks

FRIDAY—"YOUTH DAY"

3:00 p.m.	Youth Day Parade
5:00 p.m.	Bubble Gum Blowing Contest—Confederate Park
8:30 p.m.	Pageant
10:00 p.m.	Fireworks

SATURDAY—"FARMERS DAY"

10:00 a.m.	Typewriting Contest—Rock Hill College of Commerce
1:00 p.m.	Parade Line up
2:00 p.m.	Parade Starts
5:00 p.m.	Beard Judging and Prizes
8:30 p.m.	Pageant
9:00 p.m.	Queen's Ball (Fleet Green's Orchestra at Rock Hill Armory)
10:00 p.m.	Fireworks

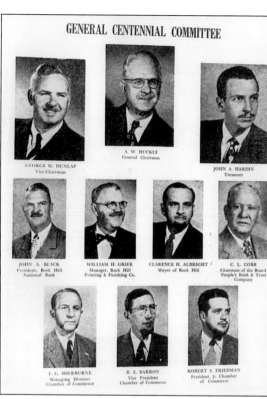

GENERAL CENTENNIAL COMMITTEE

GEORGE W. DUNLAP
Vice-Chairman

A. W. HUCKLE
General Chairman

JOHN A. HARDIN
Treasurer

JOHN A. BLACK
President, Rock Hill
National Bank

WILLIAM H. GRIER
Manager, Rock Hill
Printing & Finishing Co.

CLARENCE H. ALBRIGHT
Mayor of Rock Hill

C. L. COBB
Chairman of the Board
People's Bank & Trust
Company

E. G. SHERBURNE
Managing Director
Chamber of Commerce

R. E. BARRON
Vice President
Chamber of Commerce

ROBERT S. FRIEDMAN
President, Jr. Chamber
of Commerce

The General Centennial Committee for the Rock Hill's 100th year birthday celebration is photographed above.

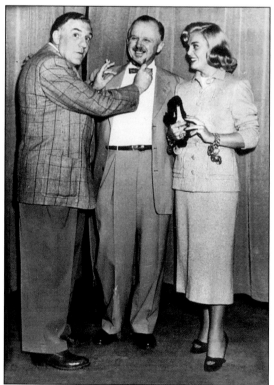

Popular actor William Bendix (left) and actress Elizabeth Scott (right) clown around with Rock Hillian Bob Bryant during the centennial celebration.

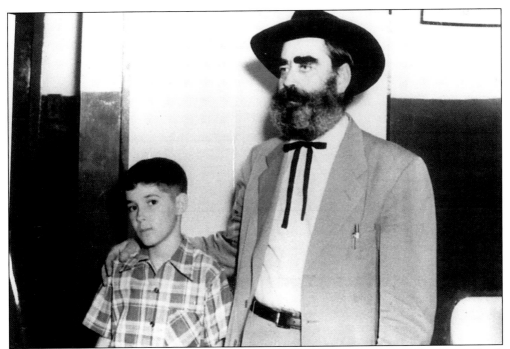

Pictured above are ten-year-old Mickey Brackett and his grandfather Dewey Brackett, a Rock Hill police officer, during the 1952 centennial activities. Mr. Brackett's beard came as a result of his participation in "Brothers of the Brush." He won the event's best all-around prize. All the men in Rock Hill were encouraged to grow a beard or mustache and dress in 1852-era clothes.

The Rauton family gets into the historic spirit and poses for a photo during the Rock Hill Centennial in 1952. From left to right are Jimmy May Lou Hope, Buzzy, James (the mother) Ed (father), Christine, and Ammie Hope.

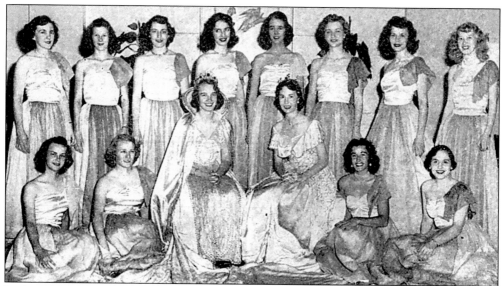

In this 1952 photograph, Miss Ellen Ussery ("Miss Rock Hill") and Miss Betty Johnson ("Miss York") pose with members of the Queen's Court. From left to right are the following: (seated) Maxine McCarter, Louise Ragin, Miss Ussery, Miss Johnson, Patsy Wright, and Dolores de Parma; (standing) Julia Belk, Joanne Neely, Jennie Boyd, Zenobia Roberts, Joanne Elder, Beth Schrader, Pat Rainwater, and Peggy Horne.

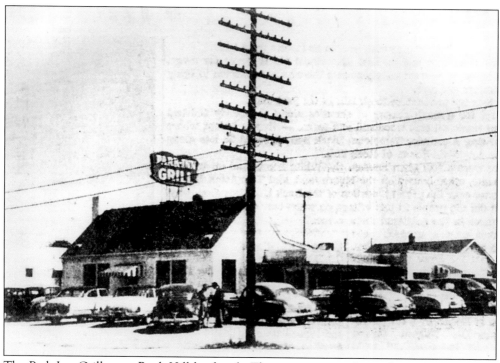

The Park Inn Grill was a Rock Hill landmark. The restaurant was located on Cherry Road in the area where the El Cancun Restaurant now stands. T.E. Neal and Andy Komar owned the Park Inn Grill, which closed in the early 1970s.

84

These photographs showcase early scenes of integration in Rock Hill—St. Anne's Catholic School on Saluda Street about 1953 (above) and St. Mary's kindergarten (right) in the mid-1950s. Local Catholic schools were leaders in integration. In fact, St. Anne's Catholic School was the first school in our city to integrate voluntarily.

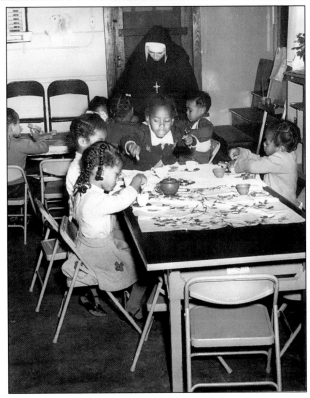

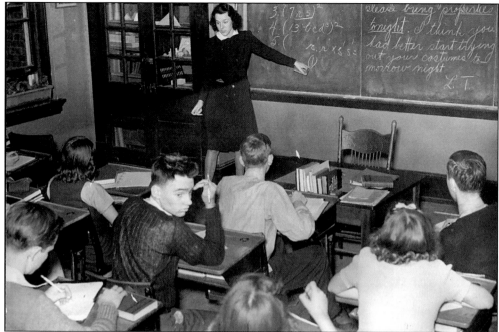

A 1953 class at the Winthrop Training School is shown above. Begun in 1913 and located in what is today the Withers Building, the Winthrop Training School played an important role in education. The school fostered innovative teaching methods and a laboratory for student teachers. The Winthrop Training School closed in 1968.

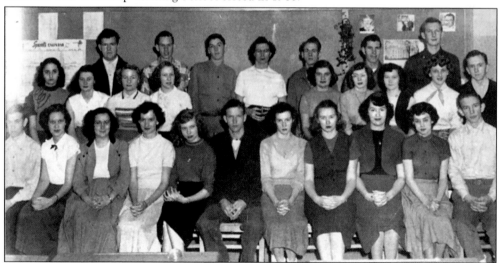

This photo from the 1953 Rock Hill *Bearcat* annual was titled "Miss Kneece's Homeroom." From left to right are the following: (first row) Robert Wallace, Delores Garrison, Sylvia McCorkle, Thelma Satterfield, Eula Mae Merritt, Frank McQuire, Edna Mae Pyatt, Annie Haire, Frances Betchler, Patricia Frye, and Billy Ramsey; (second row) Alberta Baddour, Ruth Ann Threatt, Louise Robinson. July Gauldin, Mary Ruth Roberts, Maxine Cobb, Patricia Hinson, Nancy Giles, and Walter Brown; (third row) Carroll Culp, Glenn Canady, Donald Clark, Miss Irene Kneece (the teacher), Ben Curtis, Bill Simpson, and Harry Blackwell. Not pictured are Patsy Tatham and James Ferrell.

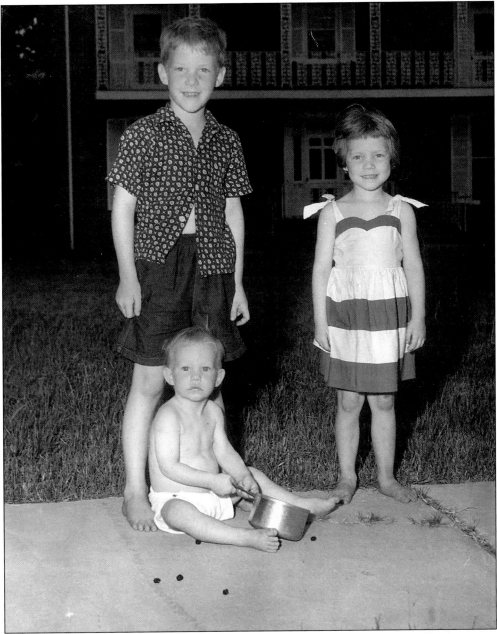

Young members of the Beaty family pose for a photo in July 1954. Standing is Bill, who is now an executive with Comporium Communications. The other two children are Robert, today an entrepreneur in Rock Hill, and Beth, who lives in Charlotte and is a homemaker. George A. Douglas, one of Rock Hill's leading photographers, took the photo.

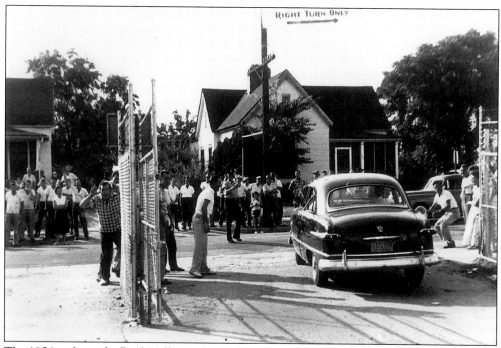

The 1956 strike at the Rock Hill Printing and Finishing Company is depicted above. The strike lasted 16 weeks before the employees went back to work.

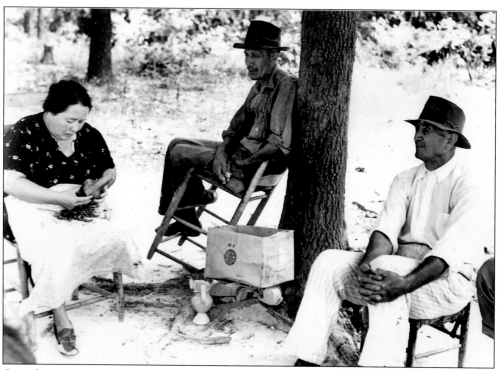

Catawba potter Liza Gordon (left) is pictured with Idle Sanders (leaning against the tree) and Chief Sam Blue. Catawba pottery has become recognized internationally as an art form.

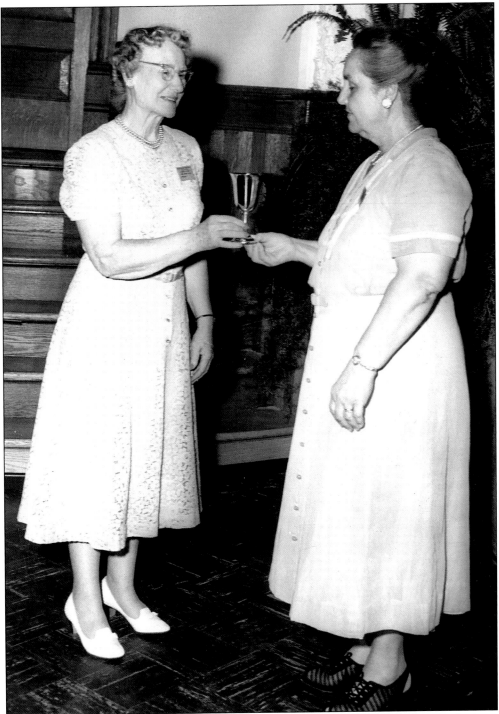

Juanita H. Neely was an outstanding local home demonstration worker, one of many who have bettered the life of South Carolinians. In 1952, *Progressive Farmer Magazine* named her "Woman of the Year." In this 1957 photo, Mrs. M.H. Lineberger, president of the South Carolina State Council, presented a silver goblet to Ms. Neely in appreciation of her service.

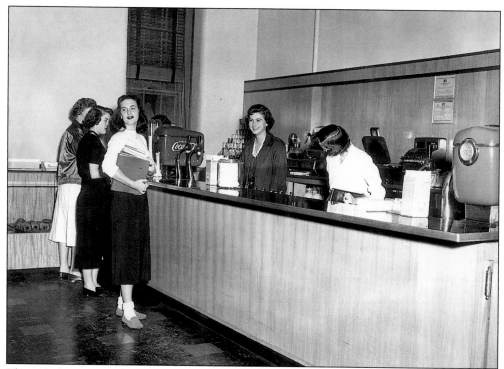

The soda fountain at the Winthrop canteen is pictured above in this 1958 photograph.

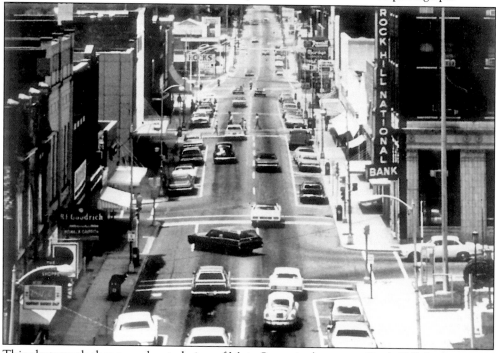

This photograph shows an elevated view of Main Street in downtown Rock Hill, looking west, in the early 1960s. Founded in 1941, Rock Hill National Bank on the left had become a major financial institution under the leadership of John A. Black and later Ben Dunlap.

Five

1960–1980

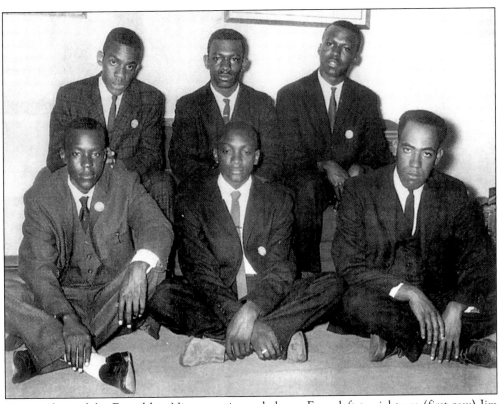

Six members of the Friendship Nine are pictured above. From left to right are (first row) Jim Wells, Willie McLeod, and Thomas Gaither; (back row) Clarence Graham, W.T. "Dub" Massey, and David Williamson Jr. Not pictured are Mack Workman, John Gaines, and Robert McCullough. The Friendship Nine staged sit-ins at the local Woolworth's and McCrory's lunch counters in 1961 to protest segregation—becoming the country's first sit-in protesters to go to jail. Their heroic efforts paved the way for de-segregation and the acceptance of equal rights.

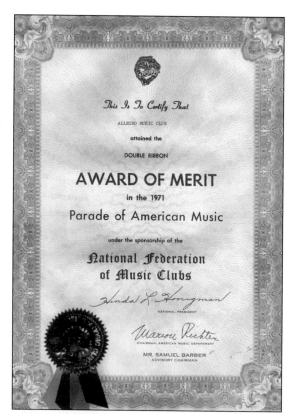

The Allegro Music Club received this award for its contribution to music in Rock Hill. Founded in 1950, the Allegro Music Club is one of several Rock Hill women's clubs that have furthered our city's cultural existence.

David Angel Sr. moved his family to Rock Hill in 1964. He operated an insurance agency until his retirement in 1993. In 1998, he received a National Service Award from the Experimental Aircraft Association for helping more than 200 children make their first air flight.

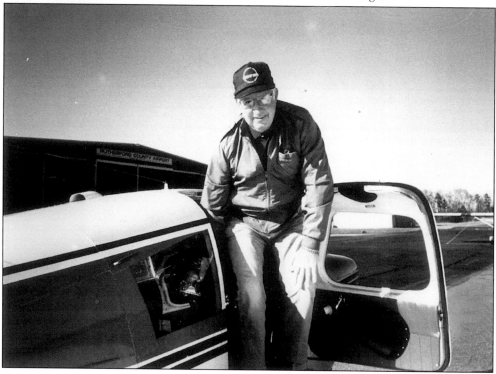

Artist Vernon Grant became famous as the creator of Snap, Crackle, and Pop, the figures that adorned the boxes of the popular cereal, Kellogg's Rice Crispies. Mr. Grant also created Glen the Frog, the noted symbol for Rock Hill's annual Come See Me Festival. Pictured to the right is an example of Vernon Grant's art.

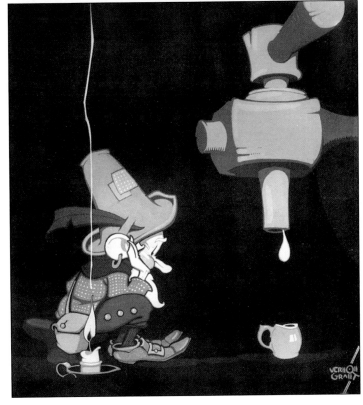

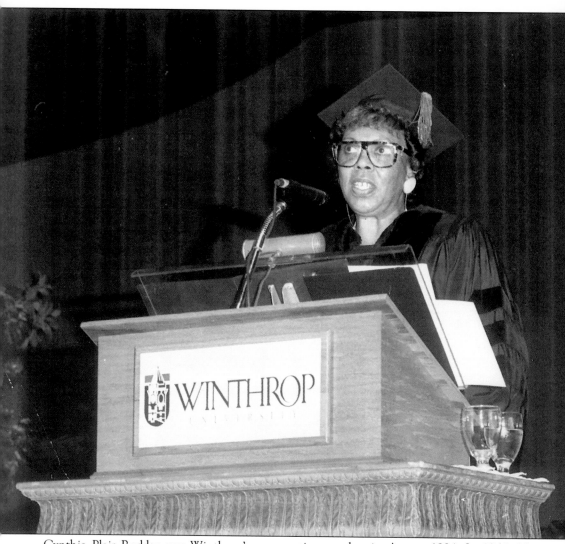

Cynthia Plair Roddey was Winthrop's convocation speaker in August 1994. In 1964, Ms. Roddey, who is a native of Rock Hill, became Winthrop's first African-American student to enroll at the college. She graduated with a masters of arts in teaching degree in 1967.

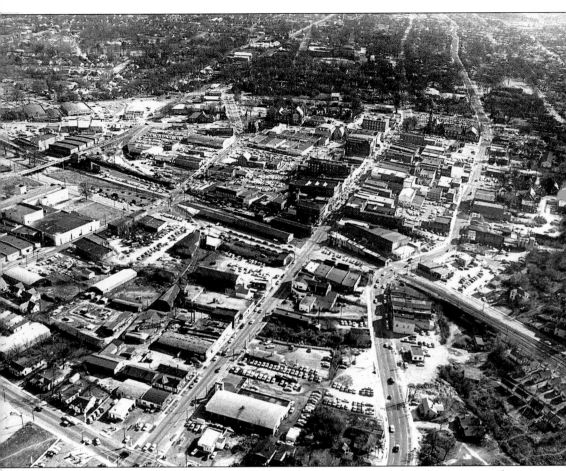

An aerial view of Rock Hill in April 1964 shows that our city was definitely growing and on the move.

A 1960s scene at Armory Park is pictured above. At the time, Rock Hill had 14 playgrounds for its young people.

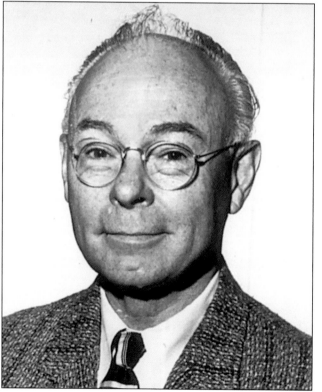

Talbert Patrick served as editor, publisher, and board chairman of the *Evening Herald* newspaper (now *The Herald*) from 1947 until his death in 1980. His son, Wayne Patrick, succeeded him.

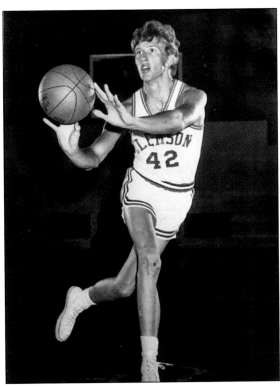

David Angel Jr. was a basketball star at Rock Hill School before graduating and moving on to become an outstanding player at Clemson University. After graduating from Clemson in 1969, Mr. Angel played pro basketball, mainly in Europe. Today, he operates an insurance agency in Rock Hill. The former basketball superstar has won the South Carolina Agent of the Year five years in a row.

After graduating from Davidson College, Moubray Beaty returned to Rock Hill and spent the years from 1936 to 1996 developing the Cherry Farms property. The Commons (formerly the Beaty Shopping Center) on Cherry Road is a big part of his legacy. This is a 1962 view of the Beaty Shopping Center, which was built in 1956. Moubray Beaty was also responsible for developing the K-Mart Plaza and the old Rock Hill Mall off of Cherry Road.

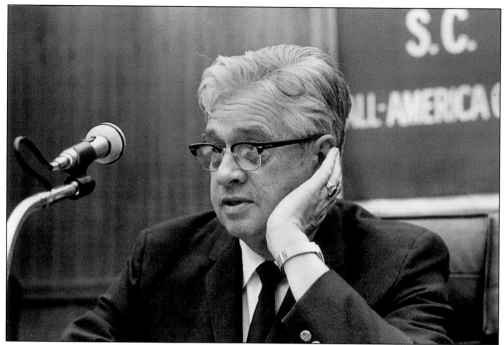

David Lyle served Rock Hill as mayor from 1964 to 1978. Dave Lyle Boulevard is named in his honor.

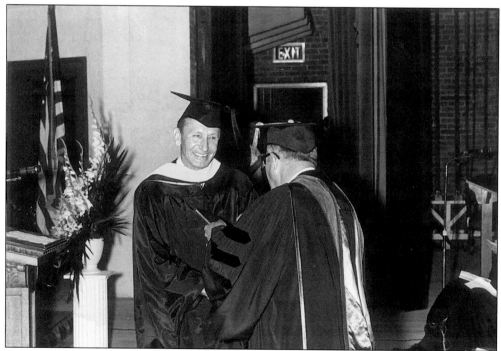

In 1969, Walter Schrader became the first man to receive a Winthrop degree, graduating with a master's degree in teaching in biology. Today, Mr. Schrader is well known as one of Rock Hill's most avid and dedicated environmentalists.

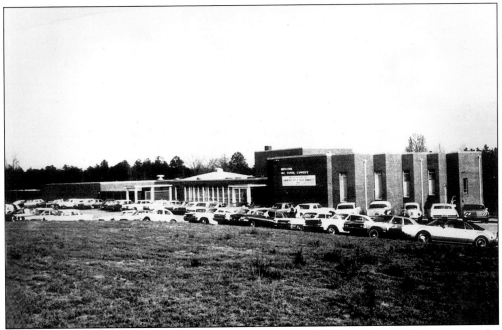

This photograph provides a 1970 view of the York County Children's Nature Museum, now the Museum of York County. In August 2000, the museum celebrated its 50th anniversary.

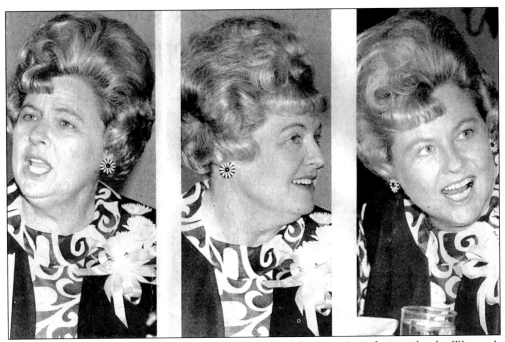

Mrs. Nash (Pauline) McKee wins the 1971 Woman of the Year Award, given by the Woman's Club of Rock Hill. These images, along with a large article, were produced in the April 30, 1971 edition of the *Evening Herald*.

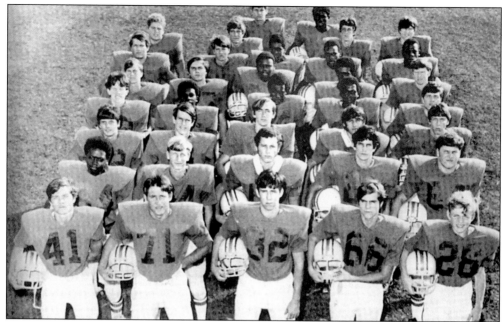

Northwestern High School's first varsity football team is pictured in this 1971 photograph. From left to right are the following: (kneeling) managers Jimmy Givens, Jimmy Fudge, Huey Smith; (second row) William McNeil, Jeff Thompson, Tommy Miller, Jimmy Kiser, Joe Edwards; (third row) Harry Hicklin, Jimmy Hoskins, Terry Laughridge, Mike Becknall, and Terry McGinnis; (fourth row) Charles Jackson, Willie McCoy, Freddie Minton, Robert Davis, and Marty Melton; (fifth row) Rocky DuBard, Mike Morton, Gerald Tate, Lafayette Ware, and Henry Moore; (sixth row) Eddie Chapman, Brown Pursley, Jimmy Lewis, Sandy Kennedy, and David White; (seventh row) Arnold Carter, Ronnie Burrell, Rick Sanford, and Bobby Mathis; and (eighth row) Gene Walden and Samuel Dunham.

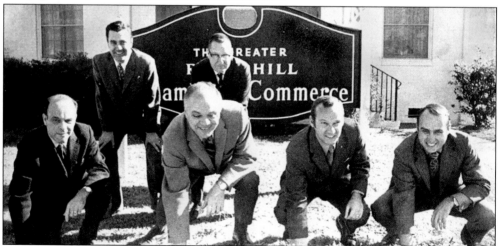

In 1971, Marshall Walker, president of the Rock Hill Chamber of Commerce, named four businessmen vice presidents of the chamber. From left to right are Ted Burwell (Community Betterment), Bob Hale (Organization Improvement), Al Adickes (Legislative Action and Public Affairs), and Ed Haws (Business Development). John Gill, chamber first vice president, is pictured in the back left and Pres. Marshall Walker is on the right.

Out of the mud

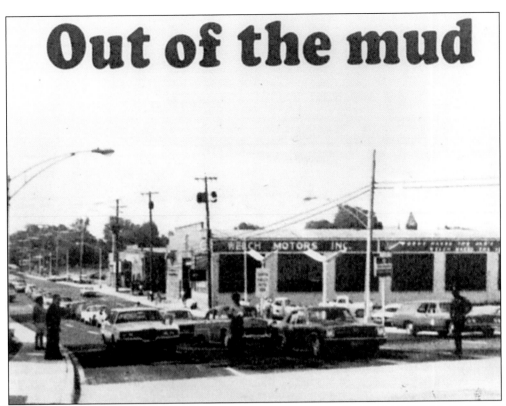

In this June 1974 photograph, cars are lined up to be among the first to cross the new Charlotte Avenue Bridge.

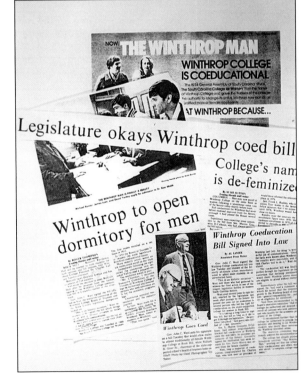

Winthrop University became a co-educational institution in 1974 and began a new, dynamic era in its history.

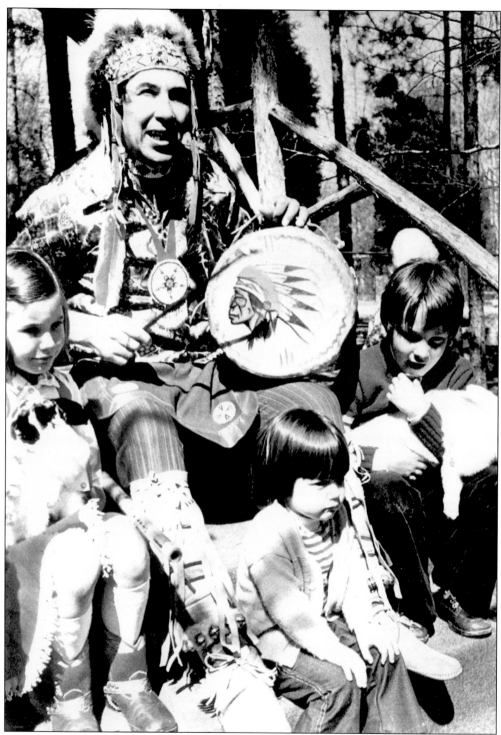

In 1975, Chief Gilbert Blue of the Catawba Indian Nation performed for little children in the petting zoo of the Museum of York County.

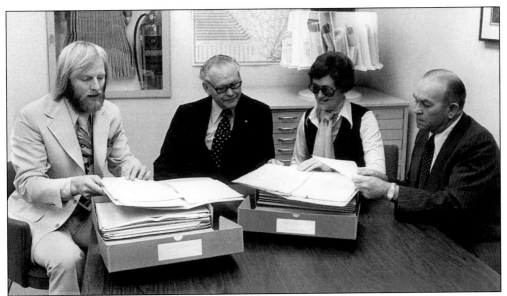

In December 1976, Robert McFadden and Tom Gettys donated their papers to the Winthrop University Archives. From left to right are Ron Chepesiuk (archivist), Shirley Tarlton (dean of the Winthrop Library), Robert McFadden, and Tom Gettys. Mr. McFadden served as a state legislator and later as a judge. Mr. Gettys served as the congressman for the fifth district from 1964 to 1974.

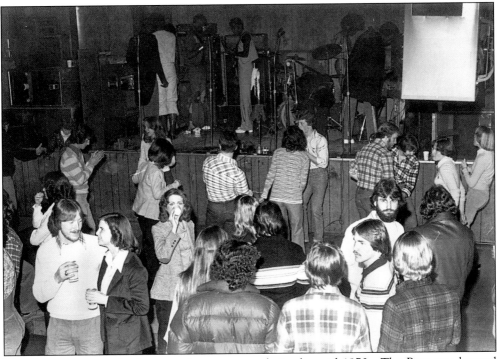

The Barn was a popular hangout for young people in the mid-1970s. The Barn was located directly across from the Winn Dixie on Highway 161. The building is now used for auctions.

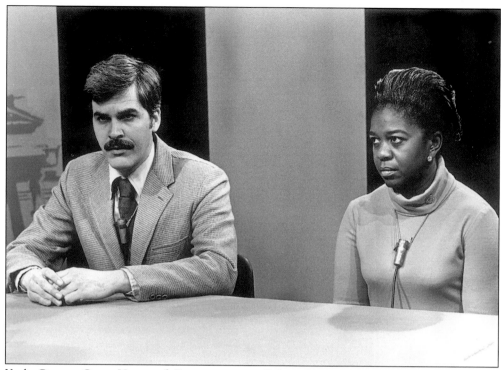

York County State House of Representatives Palmer Freeman and Juanita Goggins are the guests on ETV's "Legislative Profile." Juanita Goggins, who served from 1975 to 1978 and lived in Rock Hill, was the first African-American woman elected to the South Carolina House of Representatives.

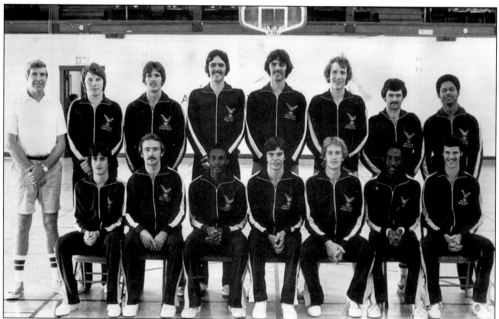

An exciting first for our community was Winthrop's 1977–1978 men's basketball team coached by Nield Gordon. Today, the Winthrop Eagles play in the NCAA's Division 1.

W.H. Witherspoon, a leading Rock Hill citizen, addressed a multi-ethnic workshop that Winthrop sponsored in 1977.

A Winthrop Class studying the multi-ethnic heritage of York County tours the White House at 260 East White Street. Now surrounded by other houses and heavy traffic, the White House was one of the first upcountry houses in Rock Hill. It was located near the main road from Charleston to Salisbury, North Carolina. Andrew White, a teacher at Castle Heights Junior High at the time, served as the tour guide.

Winthrop history professor Dr. Arnold Shankman walks across the university campus in 1978. While serving Winthrop from 1975 until his death in 1983, Dr. Shankman was a prolific scholar, an award-winning teacher, and a strong supporter of the Dacus Library and its archives.

Lindberg Moody was the first Northwestern Boys basketball coach, serving from the school's opening in 1971 until his death in a car accident on June 25, 1980. After graduating from South Carolina State, Mr. Moody played for a year with the Detroit Pistons of the NBA. His impressive 12-year coaching record with the Trojans was 129-66.

Six

1980–Present

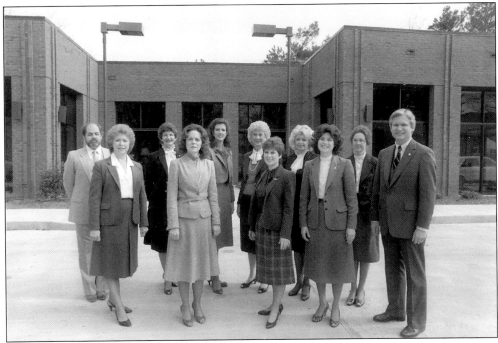

The staff of Rinehart Realty posed in front of the company's new office on Ebenezer Avenue in 1982. The success of Rinehart Realty is a reflection of Rock Hill's economic growth.

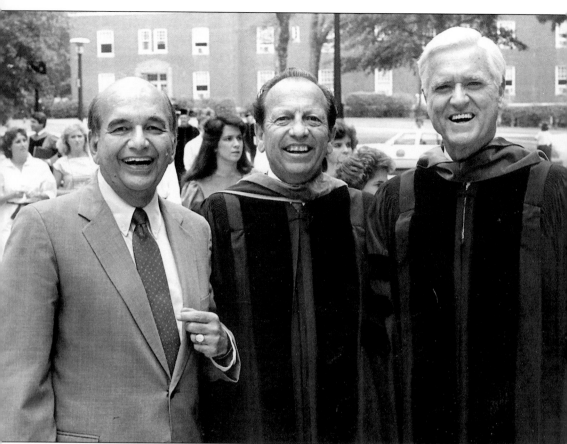

Three friends pose for a photo at the 1984 Winthrop commencement. From left to right are Connie Morton, a leading Rock Hill banking executive with the old C and S Bank; John Hardin, a Rock Hill banker and former mayor of Rock Hill; and Ernest "Fritz" Hollings, a long time U.S. senator from South Carolina.

Bill Curry, the "Voice of Rock Hill," is seen in this 1982 photograph. At the time, the prominent local media personality was working for WSOC Radio 93 AM from 4 to 7 p.m. Today, Curry also has a popular TV show seen on local station WNSC-TV.

Eric Boyd, a Northwestern High School All-American wrestler, was a two-state champion in 1981 and 1982 and president of the high school's student body.

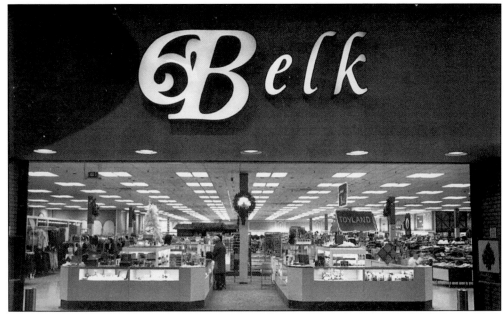

The Belk Department Store became a major anchor when the Rock Hill Mall was built on Cherry Road in the late 1960s. The anchor store was moved to the Galleria Mall when it was built in 1989. For decades the early Belk Department Store was a commercial fixture on Main Street.

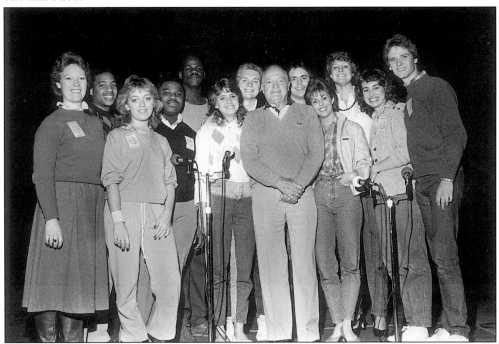

Legendary entertainer Bob Hope appears here with Winthrop students during the University's "Rededication Week" (November 9-17, 1984). Winthrop named Bob Hope an honorary Winthrop student. Numerous national dignitaries, including Rosalynn Carter and Pierre S. du Pont IV, came to Rock Hill during the festivity.

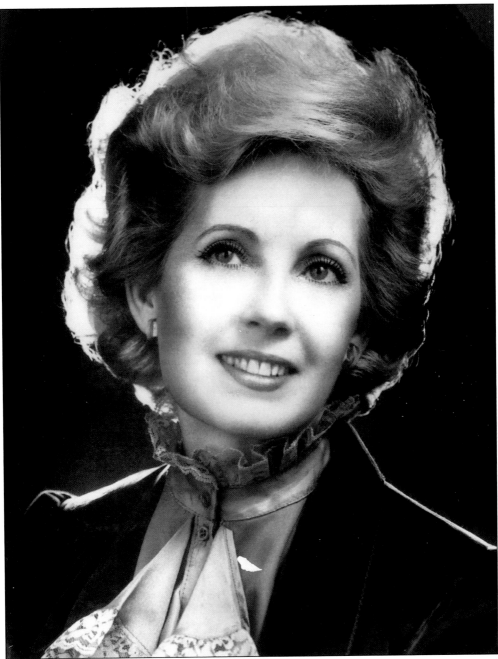

Frances Patton Statham, a native of Rock Hill, is a best-selling writer and author of several books. Her 1986 novel, *To Face the Sun*, won the National Reviewer's Choice Award for best World War II novel. She presently resides in Georgia.

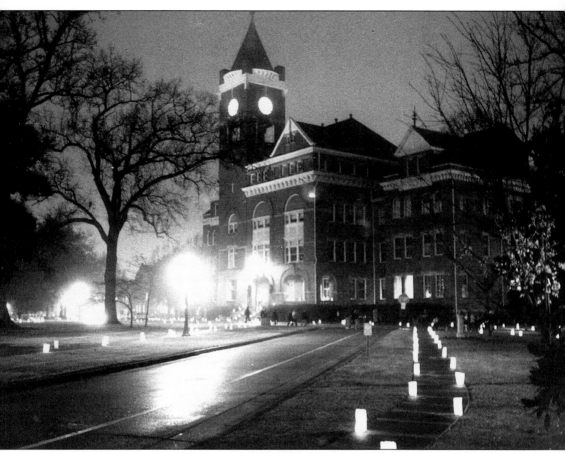

Winthrop University brightens up for the 1987 Christmas holiday season. Each year, the university sponsors popular programs for the Rock Hill community. The previous year Winthrop celebrated its 100th anniversary. By May 2001, Winthrop University was having a $146 million impact on Rock Hill and York County through the purchases of goods and services. That was the finding of a three-month study conducted by two university professors.

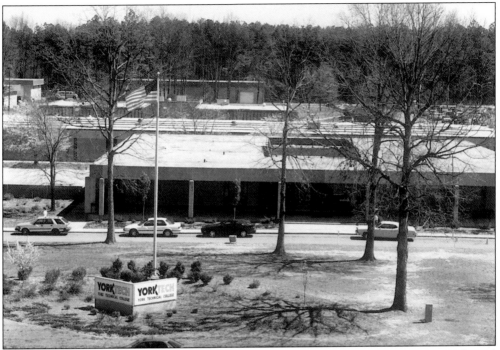

This photograph shows an aerial view of York Technical College. The two–year technical college has been a major factor in Rock Hill's remarkable development.

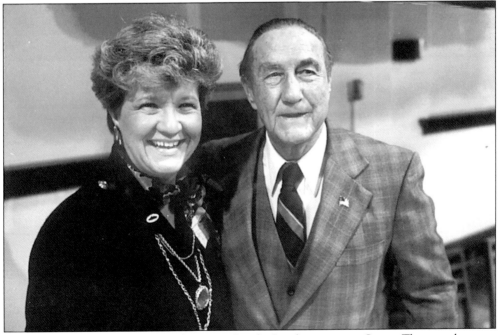

Mayor Betty Jo Rhea (left) and longtime South Carolina senator Strom Thurmond appear together in this 1986 photograph. In 1978, Ms. Rhea became the first woman elected to the Rock Hill City Council, and then from 1986 to 1996 she served the city as its first female mayor.

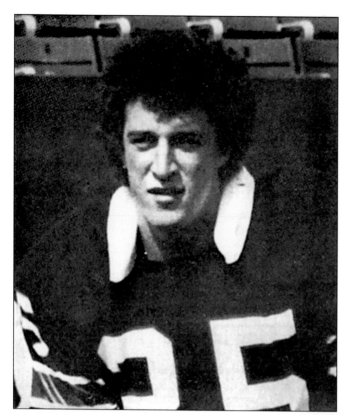

Rock Hill has produced some outstanding athletes in recent years. Two of the best are Rick Sanford, a Northwestern High graduate (left) and Gerald Dixon (below), a Rock Hill High graduate. Sanford was a number one pick of the New England Patriots and the 25th pick in the entire nation. After a seven-year career with the Patriots, Sanford graduated from chiropractic school and is now Dr. Rick Sanford. The Cleveland Browns drafted Gerald Dixon in the third round in 1992. In 2001 he was playing with the San Diego Chargers.

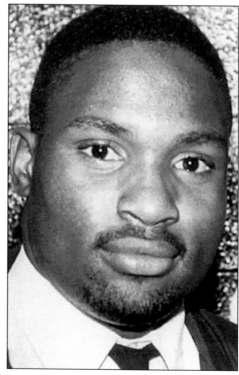

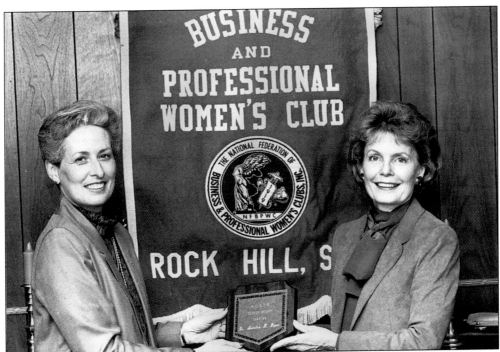

The Rock Hill Business and Professional Women's Club honored Martha Kime Piper (right), Winthrop's first female president (1986–1988) as the 1987–1988 Career Woman of the Year. The Rock Hill Business and Professional Women's Club was founded in 1925 to serve and promote the interests of Rock Hill's business and professional women.

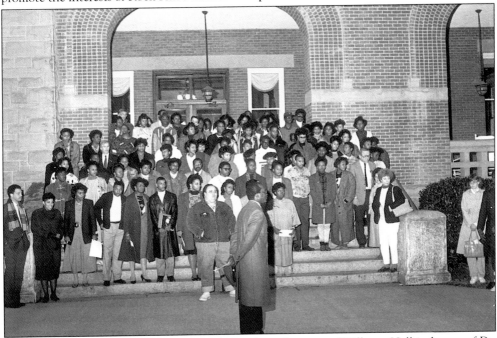

In January 1989, Winthrop students held a vigil on the steps of Tillman Hall in honor of Dr. Martin Luther King.

Baxter Hood was a major driving force behind making York Technical College a leader in community education. Mr. Hood began working in technical schools in 1964 and was president of York Technical College until his death in 1989. In 1990, York Tech named the school's continuing education conference center after Mr. Hood.

Pictured here are Harry Dalton with his wife, Becca. Harry Dalton was chairman and chief executive officer of Star Paper Tube Company until his retirement in 1992. Today, he is one of Rock Hill's leading environmentalists. Mr. Dalton has served as president of the local Henry's Knob Chapter of the Sierra Club, and has been active with the state Sierra Club and the South Carolina Wildlife Federation.

C.H. "Icky" Albright was a leading Rock Hill businessman, civil booster, and former mayor of Rock Hill, who is credited with organizing Rock Hill's first Come-See-Me Festival. Mr. Albright died on January 31, 2000.

Known affectionately as "The Old Corn Merchant," Harper Gault was a talented local columnist and leading radio personality. He was also a tireless fund-raiser for IPTAY, Clemson's athletic fund, and served as the organization's national president. Mr. Gault died in 1995.

Begun more than 20 years ago, Pilgrims' Inn has grown to a staff of 20 who are helped by dozens of local volunteers—all dedicated to helping families help themselves. In 2000, Pilgrims' Inn helped 10,832 people with emergency assistance, 226 with shelter or housing, and 136 with child care programs. This 1992 photo shows John Brezelle Sr., at the time a Winthrop senior, in Pilgrims' Inn's daycare center.

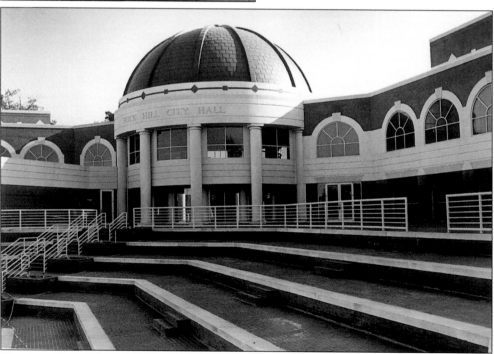

This is a classic photo of city hall, the heart of Rock Hill government. This building was dedicated on December 24, 1992.

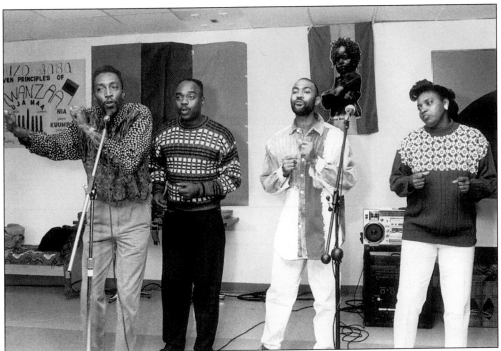

As this 1992 photo shows, Kwanzaa is a major celebration at Winthrop University. Kwanzaa is a cultural holiday first celebrated on December 26, 1966, and is traditionally held from December 26 to January 1.

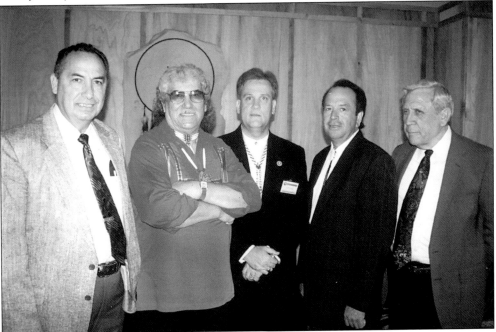

The Catawba Tribal Executive Committee steers the future of the Catawba Nation. From left to right are Assistant Chief Buck George, Chief Gilbert Blue, committee member Dewy Adams, Secretary and Treasurer Carson Blue, and committee member Claude Ayers.

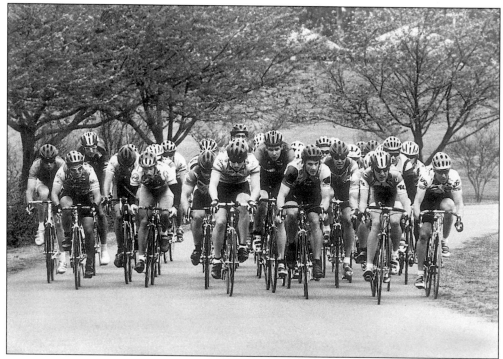

Seen above is a photograph of the bike race for the 1998 Come-See-Me Festival, a Rock Hill event that has brought national recognition to the city.

The United Way kicks off its 1998 fund-raising campaign in this photograph. The Wash Tub Race is an annual event. The perennial success of our city's United Way drive exemplifies the generous spirit of our community.

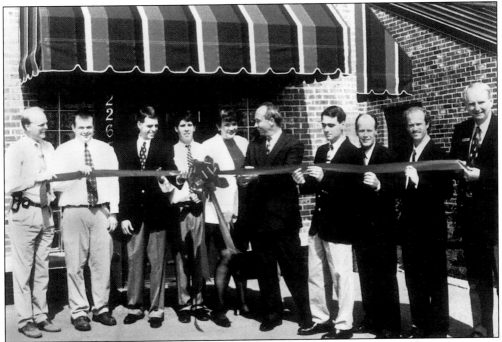

Rock Hill is on the move. The Chamber of Commerce participates in two ribbon cuttings in the late 1990s—O'Charley's Restaurant on July 6, 1998 (above) and The City Club on April 29, 1998 (below)—as our thriving city continues to attract industry and business. Bill Neely at front left spearheaded the development of the City Club in downtown Rock Hill.

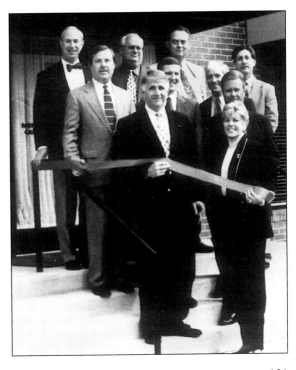

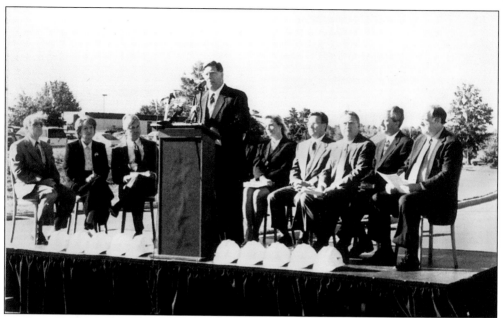

Mayor Doug Echols, who won re-election in the fall of 2001, addresses those in attendance during the groundbreaking ceremony for Piedmont Health South in August 1999.

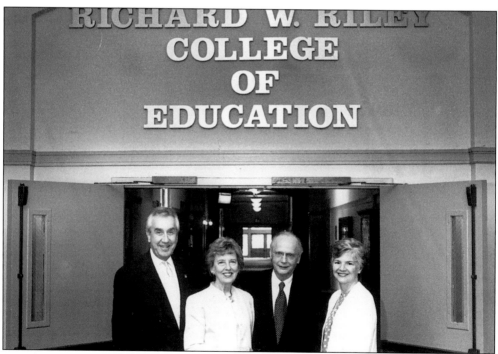

From left to right are Anthony DiGiorgio, (president of Winthrop), Ann and Dick Riley, and Gale DiGiorgio (wife of president DiGiorgio). In May 2000, Winthrop named its College of Education after Mr. Riley, a former South Carolina governor and a secretary of education during the Bill Clinton presidential administration. For more than a decade, President DiGiorgio has steered Winthrop through a period of remarkable growth.

122

Main Street Live, an event that has become a popular gathering of city folk, is shown in this August 2001 photo.

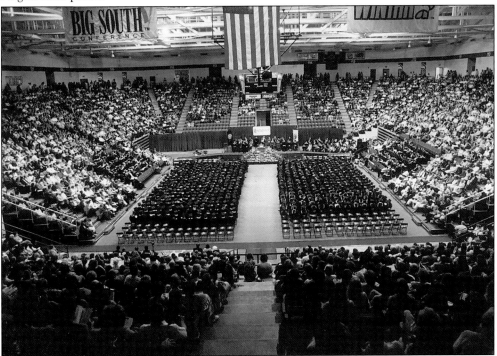

The Winthrop Coliseum is jam packed for the university's May 2001 commencement. Winthrop registered a record breaking 6,000+ students for the 2001–2002 academic year. The future looks bright for the university, guaranteeing it many more overflowing commencements.

Wayne T. Patrick, former owner and publisher of *The Herald*, was also an active civic leader and philanthropist. Mr. Patrick came to Rock Hill after his father, Talbert Patrick, bought the paper (then *The Evening Herald*) in 1947 from A.W. Huckle. Wayne Patrick was publisher of *The Herald* from 1970 to 1993. He died on September 21, 2001.

Established in 1975, "For What It's Worth" was a popular downtown restaurant and bar until its closing in 2001. Peter Valencic, the establishment's owner, is behind the bar.

Located on Cherry Road, Scandals has been a popular hangout for young people since the late 1970s.

A business expo that was held in 2001 is shown in this photograph. Not satisfied to rest on its laurels, Rock Hill continues to look for new opportunities. The York County Regional Chamber of Commerce sponsors a business expo in the spring each year as part of the Come-See-Me Festival. The expo is representative of the diversity and growth of Rock Hill's business community.

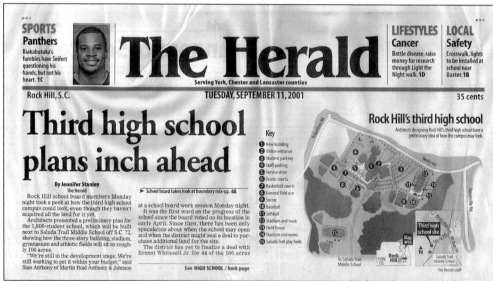

Headlines from *The Herald* are seen above. A third high school located off Saluda Road is scheduled to open in 2005. The two existing high schools, Rock Hill High and Northwestern, have more than 2,000 students each. One of the fastest growing cities in South Carolina with a population of nearly 50,000, Rock Hill moves toward a bright future as it celebrates 150 years of progress.

ACKNOWLEDGMENTS

Many people and institutions in the Rock Hill community have helped make this book possible. The author would like to thank the people who have contributed photos for the book and they are as follows: David Angel, Jim Basemore, Bill Beaty, Jane Brackett, Libby Brown, Chuck Chorak, Charles L. Cobb Jr., Christine Rauton Cogburn, Fred Faircloth, Walter Hardin, Hugh Harrelson, Jack Hood, Lynn and Clarence Hornsby, Beverly Haire, Dub Massey, Billy Ann McKellar, Roddey Miller, Brent Moorhead, Thorn Neely, Terry Plumb, Wayne Porter, Sam Rhodes, Pete Valencic, and Sandra Williams Webster. The following institutions also helped the author locate photos for this book: the Catawba Nation, Rock Hill Coca Cola Bottling Company, Comporium Communications, *The Herald*, Rock Hill Telephone Company Museum, St. John's United Methodist Church, York County Library, York County Regional Chamber of Commerce, and York Technical College.

With regard to researching this book, the author would like to give special thanks to Mary Mallaney, librarian of the York County Library, and Sharon Olthof, librarian at *The Herald* newspaper. Mary and Sharon patiently spent time locating and identifying photos for the author. Also, thank you to David Lyon, director of the York County Library, for allowing access to the library's outstanding local history collection, and Page Hendrix and Elizabeth Ellis, librarians, for helping with reference requests. The York Library, its staff and resources, is one of our community's greatest assets and the author appreciates its great help over the years.

Many people at Winthrop University also helped make this book possible. President DiGiorgio and Vice President Melford Wilson were supportive throughout the project and made resources available to the author. Rebecca Masters, assistant to the president for public affairs, was especially helpful with locating photos and serving as liaison to the governor's office. Thanks to Judy Longshaw and Joel Nichols in the University Relations Office for help in making copies of original photos for the book. Magdalena Chepesiuk and Bill Beaty proofread the manuscript. Bill Beaty and Thorn Neely generously gave of their time helping the author to verify information. Mark Herring, the dean of the library, gave the author some leave time to complete the project.

Over the past 30 years, many donors have given the Winthrop Archives valuable material relating to the history of our community and this includes photos that have been used in this book. The author and Winthrop University appreciate their help in preserving our community's history.

Finally, thanks to Gov. Jim Hodges, John Hardin, and Dr. Anthony DiGiorgio for contributing xt to this book. They have given this book a special touch.

The generous support that helped the author complete this book reflects the great spirit that ·meates our community. Let us celebrate 150 years of progress!

Ron Chepesiuk
Professor and Head of the Winthrop University Archives

ABOUT THE AUTHOR

Ron Chepesiuk, scholar, author, and journalist, has been professor and head of the Winthrop University Archives since 1973. He is author of 17 books and more than 2,500 articles that have appeared in such publications as *Modern Maturity, USA Today, Columbia Journalism Review, New York Times, National Review,* and the *Bulletin of Atomic Scientists.* His other local history books include *Winthrop University* (Arcadia, 2000) and *The Scotch Irish: From Ireland to the Making of America* (McFarland, 2000).